CREATIVITY

A GLOBAL FLORAL INTROSPECTIVE

CURATED BY JULIA MARIE SCHMITT
AIFD, CFD, ICPF, EMC, PFCI

Wildflower.Media

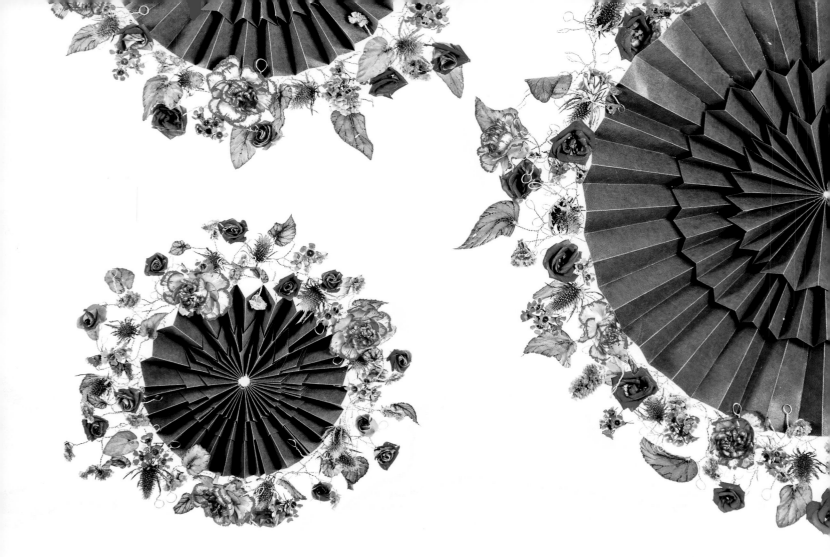

Publisher: Travis Rigby

Author: Julia Marie Schmitt AIFD, CFD, EMC, ICPF, PFCI

Editors: Robin Avni, David Coake

Art Director: Kathleen Dillinger

2020, WildFlower Media, Inc.

Topeka, Kansas. floristsreview.com

Printed in China

ISBN 978-1-7337826-5-4

(Front Cover) Design by Tomasz Max Kuczyński; Photography by JJens Poulsen, Blomster
(Back cover, from left) Design by Tom De Houwer; Photography by Thomas Nagels and Ivan Deams
Design by Agna Maertens EMC; Photography by Agna Maertens EMC and Jorge Uribe AIFD, CFD, EMC

Preface

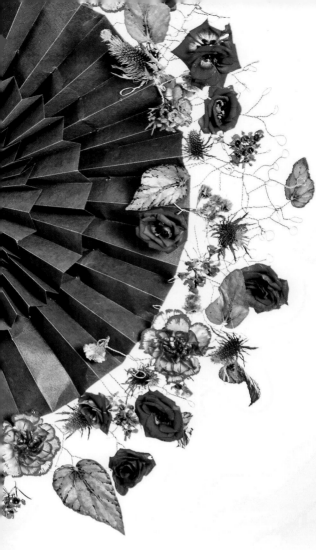

CREATIVITY is a wellspring of Human Imagination.

To CREATE is unique to the life experiences of each individual.

'CREATIVITY - A GLOBAL FLORAL INTROSPECTIVE' brings to life a collection of works by a talented stable of Flower Artists from around the world, each with their own global perspective.

These Creatives re-fashion what already exists.

They re-mix.

They see the unseen combinations.

They change direction.

They push boundaries...

They inspire!!

Immerse in their inspiration through these pages!!

Internalize their "Creative Spirits"

Creativity belongs to all of us.

Hitomi Gilliam AIFD

"Breathe Nature and her rhythms, think and try, follow your idea and intuition for 80% and let unexpected things surprise you for 20%."

Moniek Vanden Berghe
Belgian Master Florist
Owner of Cleome ı Moniek Vanden Berghe
Lovendegem, Belgium.

Introduction

When we stand before a piece of art in a museum or find ourselves drawn to an amazing display in a flower shop window, our common response always seems to be: "They are so creative!" We know instinctively when we are in the presence of creativity because that artist has been able to take something ordinary and see the potential to create something extraordinary. Through his or her concept, we are privileged to "see" their imagination come to life.

Now, if you ask that same on looker to define the term "creativity" then that individual, as well as you and me, would be hard pressed to clearly or concisely give a definition. Thanks to our dear friend the Webster Dictionary, creativity is defined as "the use of the imagination or original idea, especially in the production of an artistic work." This is wonderful but we beg to ask the question, what really does it take to be creative? Creativity, being limitless, crosses all boundaries, geography, ages, cultures, time, space and professions. Inspiration that is the seed for creativity is as unique and personal as the individual creating. It is there waiting for anyone who is open to possibilities.

Within the pages of this book, you will have the opportunity to explore the concept of creativity within the theme of a global introspection. This internationally talented pool of designers will take you on a creative journey where you will experience, through their ingenuity, how floral artists are influenced by their native lands and, for many, the countries they now call home.

Within the floral industry, be it as a floral artist, a wedding designer, a retail flower shop owner, a floral arranger or a DIY floral hobbyist, people and places inspire the designer to create. Like creativity, the inspiration from each floral designer is personal and unique. The designers speak through their floral art and let their art speak for them. Their work gives us a glimpse into who they are as people and what passions drive them to design. For the international floral artist, being creative is seen as being inspired and being inspiring.

It is that something ingrained within the designer's DNA to see beyond the normal and to live, breath and exist outside the preverbal "box" and sometimes without the confines of a "box". By imagining the possibilities of something original, they are sharing themselves with us. Many times, the floral artist borrows from another area of personal expertise and reinvents it into something beautiful and inspiring. He or she draws upon inspiration found within his or herself, from nature, architecture, fine arts, from a previous occupation or a common object like an ice cream cone. The list and more importantly, the possibilities are endless. What is important is the floral artist sees potential beyond the here and now to create something spectacular for us to gaze upon.

These artist hail from all corners of the globe: Asia, the Middle East, Europe, North and South America. Their inspiration is drawn from indigenous botanicals, beautiful landscapes, changing seasons and social culture. Each country's heritage plays a large factor in how an artist perceives reality and translates that into a tangible concept.

Within the pages of this book, you will have the chance to experience a new generation of floral designers who are willing to live their creative dreams outside the norms of convention. Whatever the source of their genius, they all have one thing in common, they are fearless in their pursuit of answering to a higher calling of discovery. By doing so, they are rising the awareness of what floral art can be.

Julia Marie Schmitt
AIFD, CFD, ICPF, EMC, PFCI

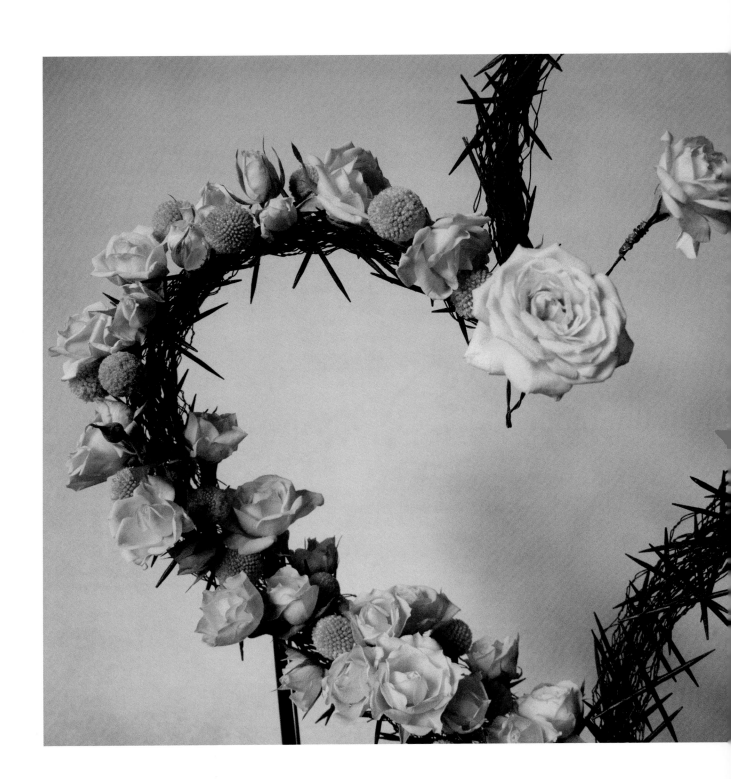

Contents

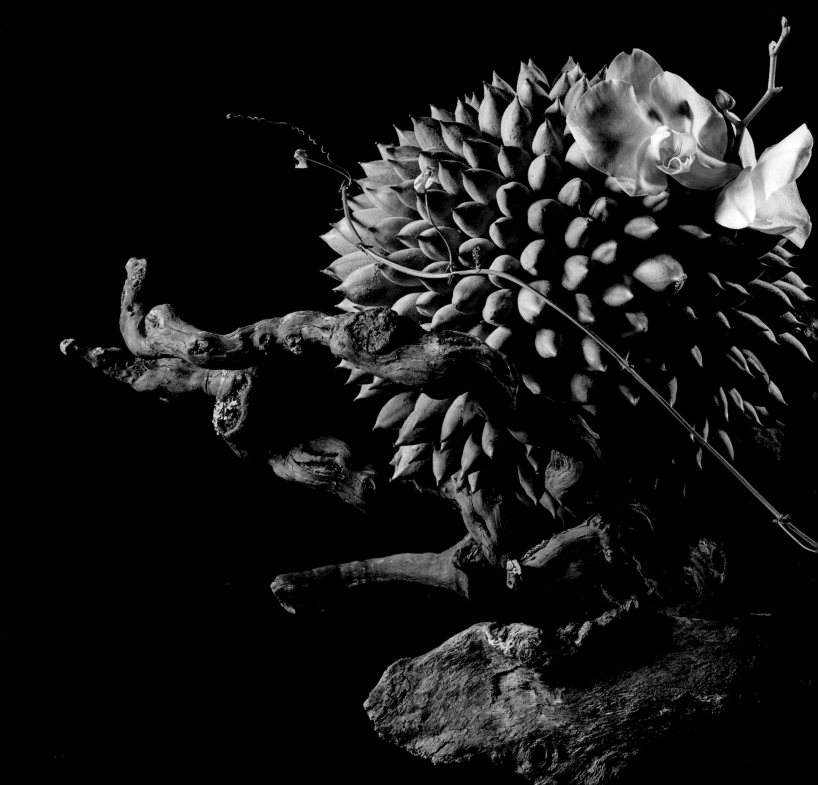

INTERNATION

Floral design by Tuba Belgin Oskan EMC
Photography by Nurdan Usta and Irem Tanman

L DESIGNERS

SOLOMON LEONG AIFD, CFD, PH.D.

[HONG KONG]

A Doctor of Philosophy in cultural studies, Solomon is the owner of SOLOMON BLOEMEN Design Studio in Hong Kong. He is an avid floral teacher to anyone who is interested in learning about flowers.

Photography by: Robin Yip

TECHNIQUE TIP:
To create the bouquet,
stack 4–5 pieces of folded
skeletonized leaves together.
Glue them to a pre-made base,
trimming the leaves to the
required size and shape. For a
large bouquet, 8,000–9,000
leaves are necessary.

SOLOMON LEONG AIFD, CFD, PH.D.

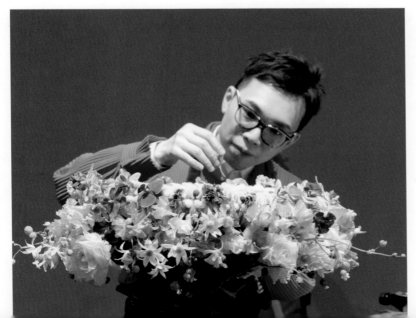

"My biggest inspiration is
the ever-changing seasons.
The smells, temperature, colors,
lights and feelings of each
season inspire me."

SOLOMON LEONG AIFD, CFD, PH.D.

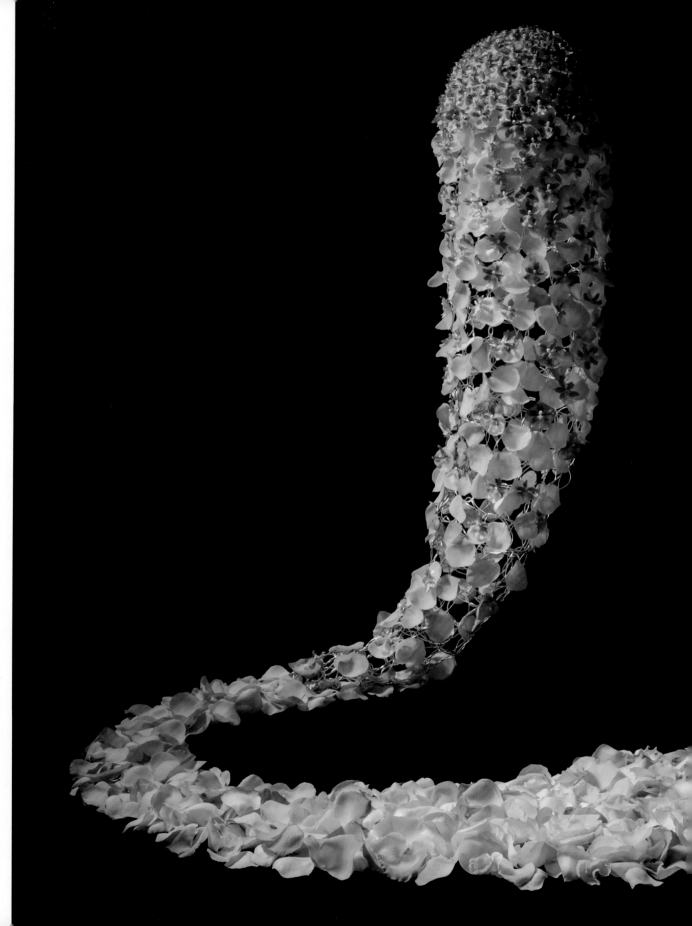

CREATIVITY: A GLOBAL FLORAL INTROSPECTIVE

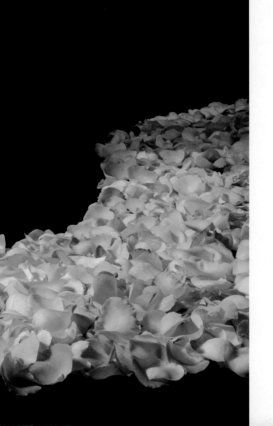

THOMAS SPIESS EMC [SWITZERLAND]

A young Swiss Master, Thomas is an expert in the realms of Floral Design, Interior Designing and coaching. He is an International Floral Designer and Mentor with a passion for sharing his knowledge and skills through workshops, seminars and courses. With the founding of numerous companies in his native Switzerland, his singular goal is to inspire florists worldwide so that they can reach their full potential in creativity while working within the most beautiful profession in the world.

Photography by: OU Zhitu Alice and Thomas Spiess EMC

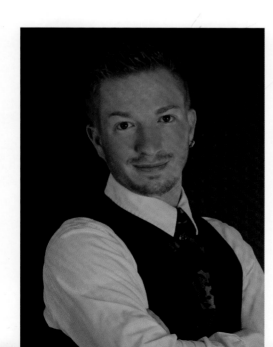

"My creativity is strongly influenced by music. Music surrounds me all day long. I am also motivated by optical stimuli, especially advertising posters. This is a strong fascination for me. My friends are a great source of inspiration and usually they even don't know it! Just by talking with them about something becomes the direct path to an idea."

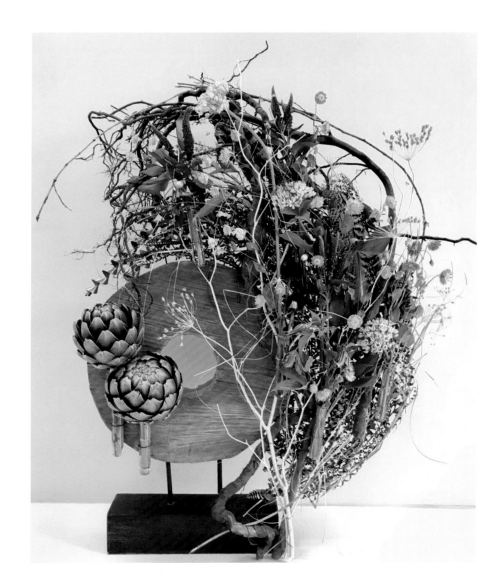

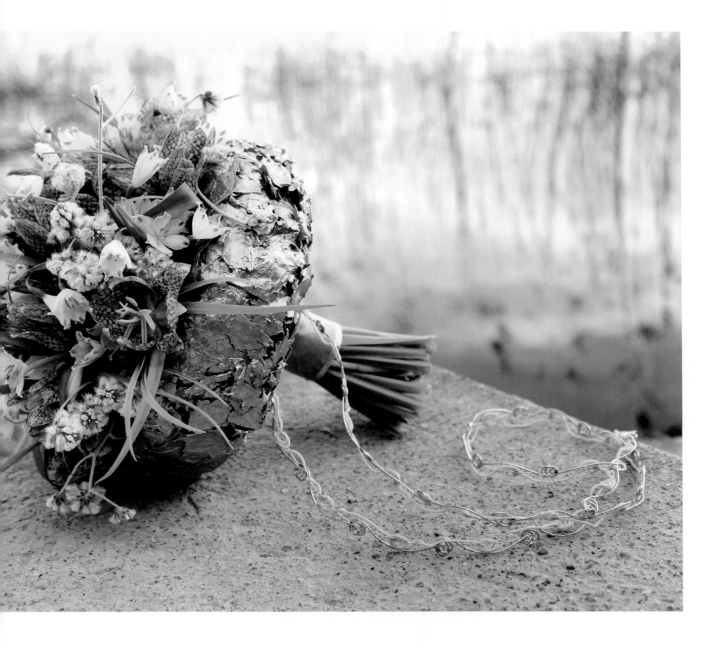

THOMAS SPIESS EMC

TECHNIQUE TIP:
When creating a construction
or armature for a bridal bouquet,
glue onion skin to a styrofoam ring
using wood glue. For a fast dry, use
a blow dryer. Then spray paint the
onion skin gold.

"I live on a kibbutz,
a pastoral agricultural
village, full of trees,
foliage and nature.
I love being in nature
while listening to
my favorite songs.
The change of seasons,
life experiences and
my surroundings give
me wonderful daily
inspiration for my
designs."

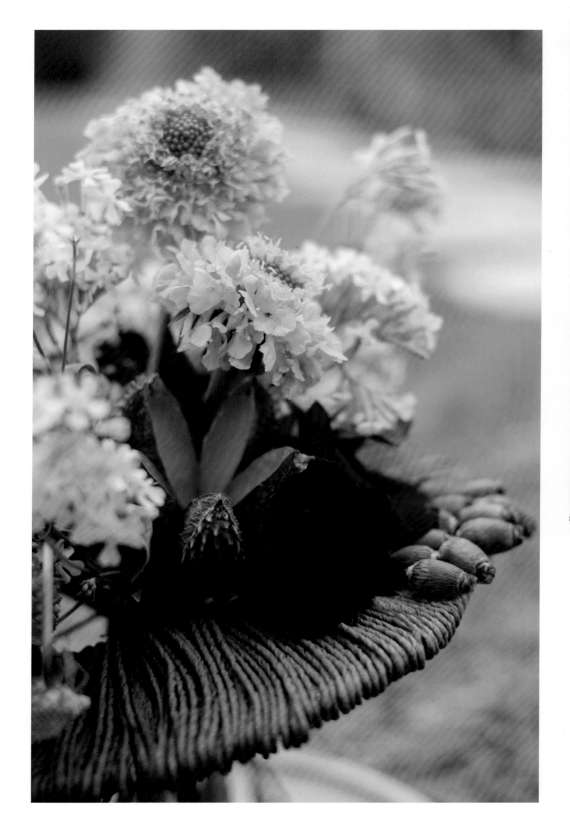

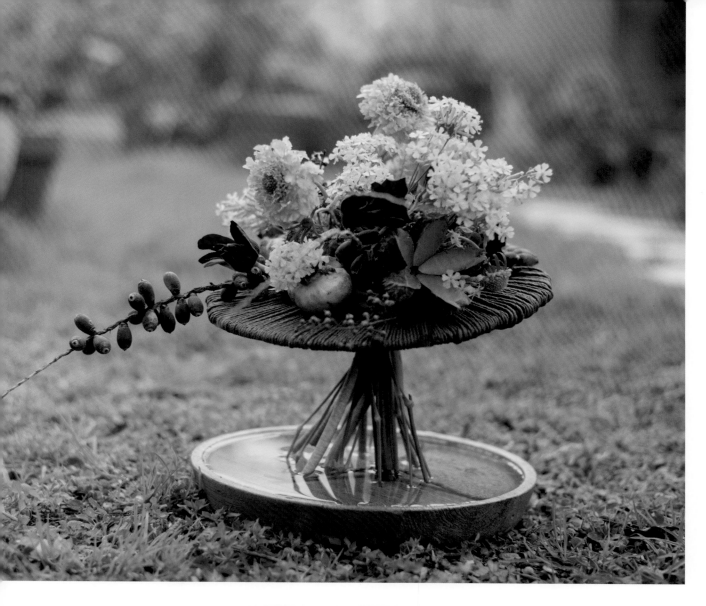

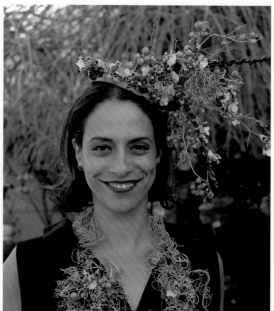

ORIT HERTZ EMC [ISRAEL]

An event and freelance designer, Orit owns Orit Hertz – Floral Design in Kibbutz Naan, Israel. After leaving her high-tech career, she has dedicated her life to offering educational courses, continuing her floral education and creating floral art.

Photography by:
Hila Meyuhas Vineberger, Shay Keden Photography,
Meital Solomon Photography, Ilanit Turgeman
Photography, Orit Hertz EMC

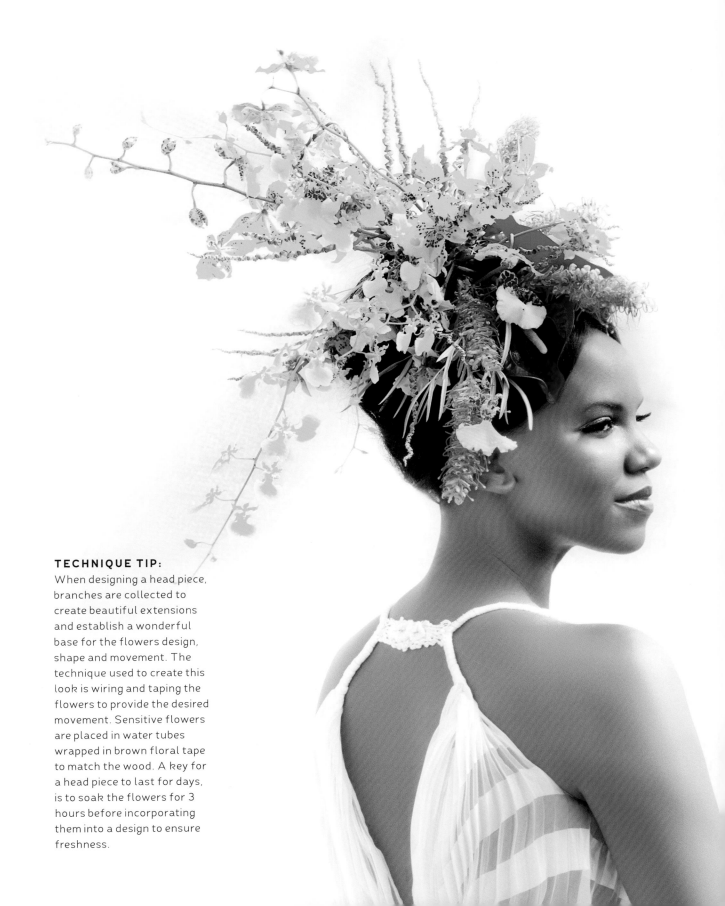

TECHNIQUE TIP:

When designing a head piece, branches are collected to create beautiful extensions and establish a wonderful base for the flowers design, shape and movement. The technique used to create this look is wiring and taping the flowers to provide the desired movement. Sensitive flowers are placed in water tubes wrapped in brown floral tape to match the wood. A key for a head piece to last for days, is to soak the flowers for 3 hours before incorporating them into a design to ensure freshness.

20

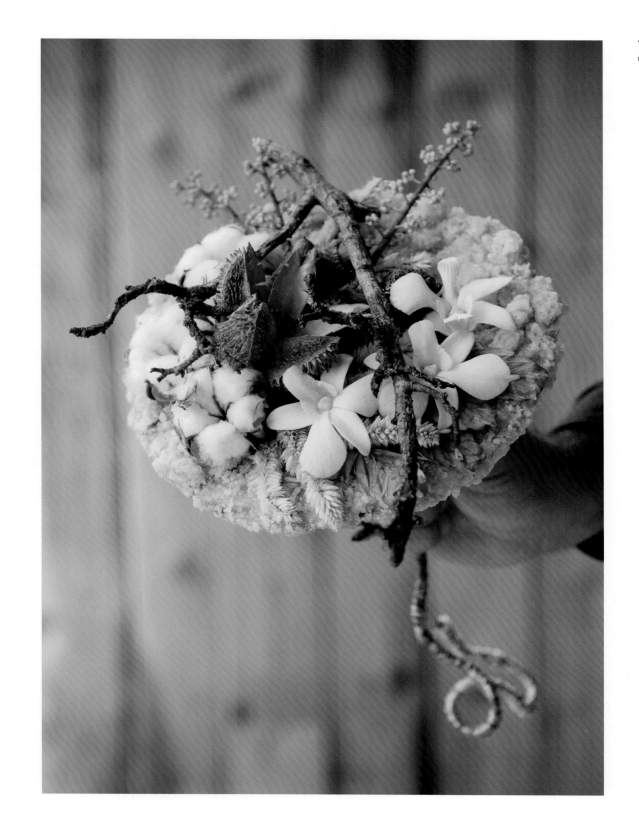

TOM DE HOUWER [BELGIUM]

A graphic designer by education, Tom wanted to find another way to express and develop his creativity. A retail flower shop owner for 20 years in Beerse, Belgium, he changed his floral career path and now dedicates himself to cutting-edge design projects and creating a floral design course to teach and mentor florist all over the world.

Photography by: Thomas Nagels and Ivan Deams

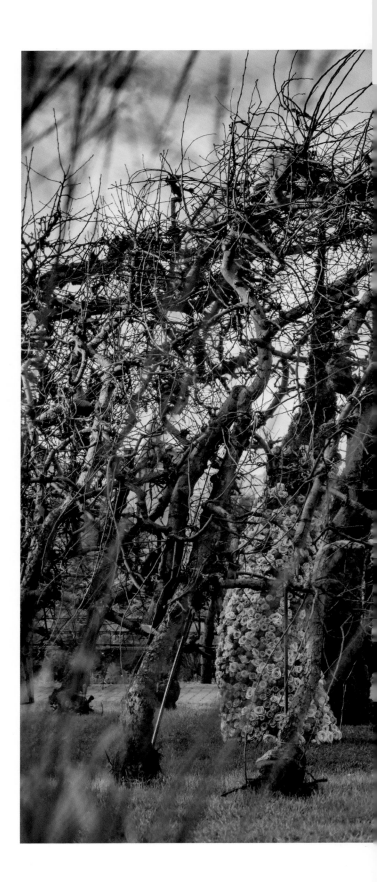

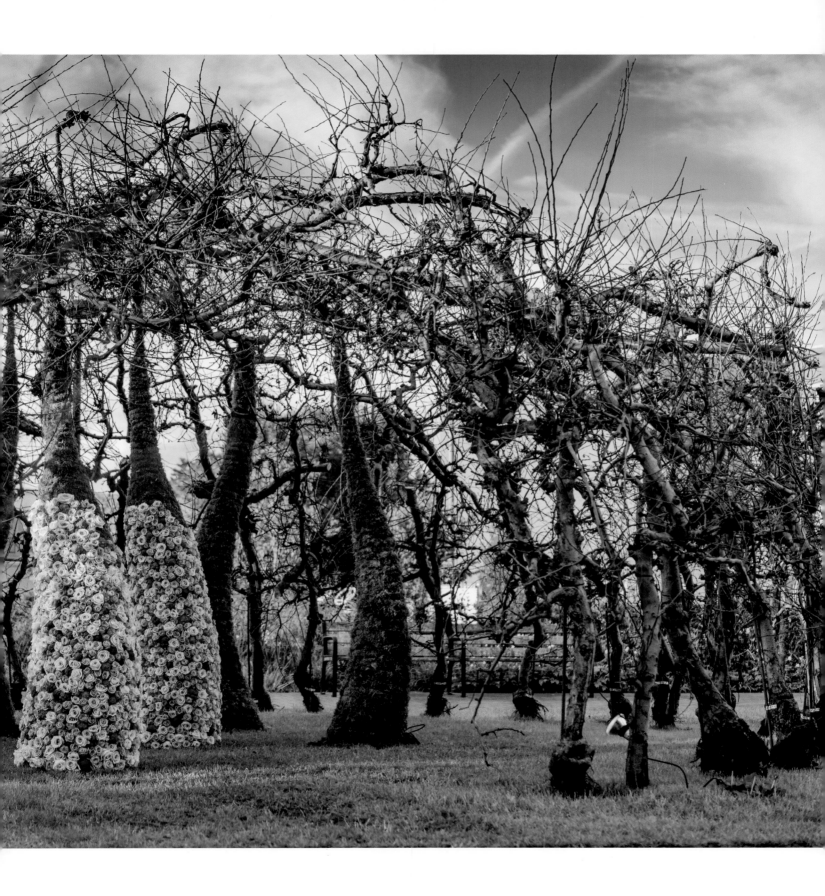

"There are two creativity in The aesthetic the technical equally

main types of floral design. creativity and creativity both important."

Tom De Houwer
Belgian Maste Florist
Freelancer and Educator
Beerse, Belgium

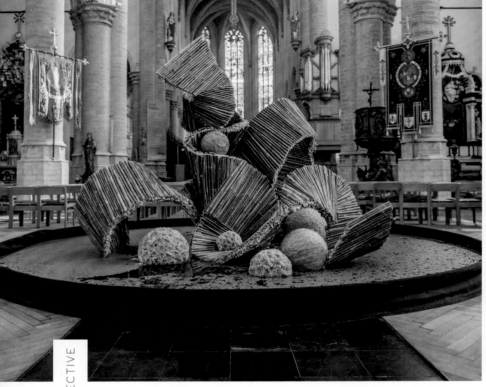

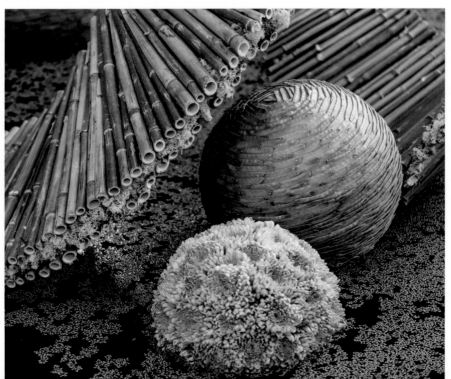

TECHNIQUE TIP:
My message to floral designer all over the world is do not seek a new technique. Seek a beautiful idea you can fall in love with and a new technical idea will reveal itself in the pursuit of beauty.

"As floral artists and designers we are the servants of beauty. Therefore, beauty is the main goal. Techniques and mechanics are there to support beauty and it should not be dominated or distracting unless the mechanics contribute to the beauty. Creativity is like a heartbeat. The status quo of our rational minds."

TECHNIQUE TIP:
In order to create a structure, use the
chicken wire and shape the wire to fit
your base. Secure the wire by stapling
it to the base; you will also attach
the water tubes to the base. You can
cover your mechanics by weaving the
branches into the chicken wire.

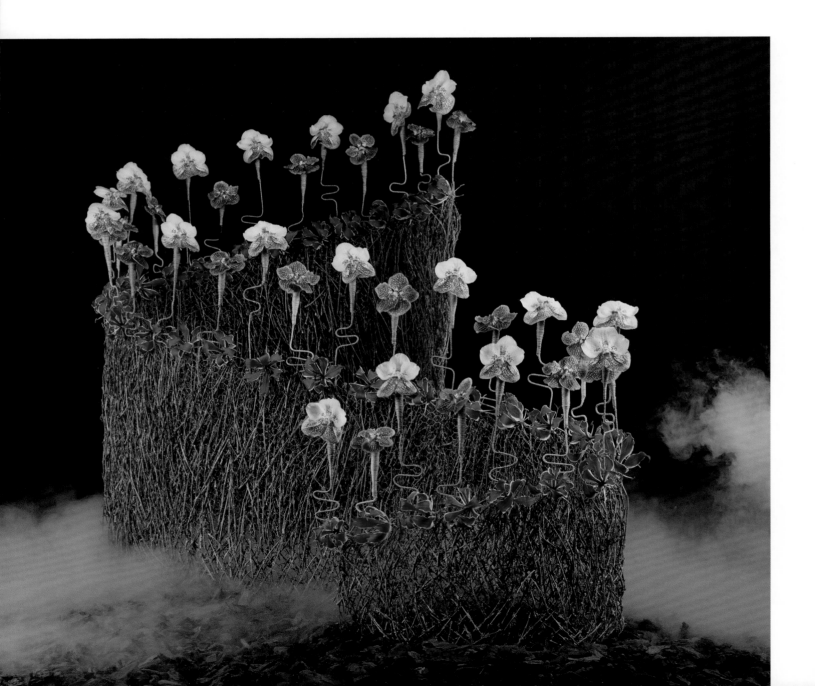

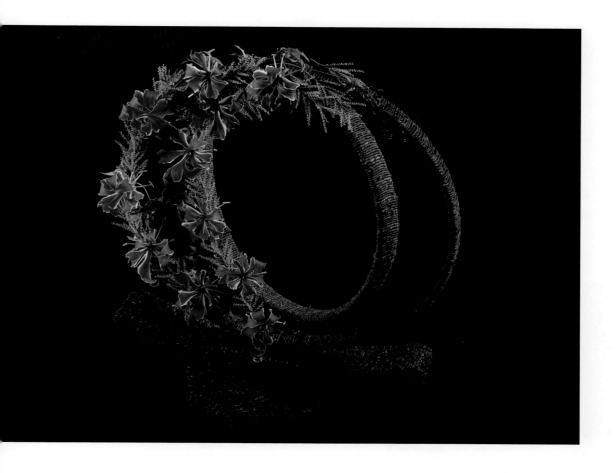

FLAVIA BRUNI CFD, EMC [ITALY]

A floral designer for years, Flavia is the owner of Flavia Bruni Floral and Designs in Rome, Italy. She is a dedicated floral educator who has established the Daisy Floral School and The Wedding Floral Academy in Italy.

Photography by: Mario Pirozzi

"My creativity has always been the fruit of what I carefully observe from my surroundings. I am lucky to live in Italy, which is defined by many as the "Bel Paese". It is full of different landscapes but also is rich in art, history and traditions. This is where I find different details that inspire me which I transform into my floral projects."

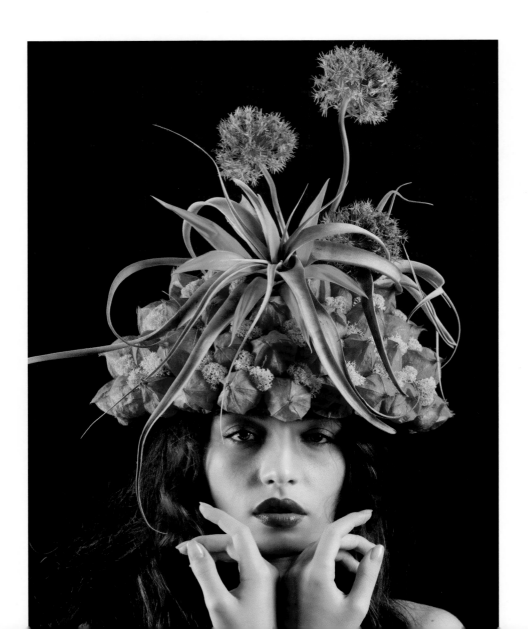

"Creativity, an inspiring journey on the way to new design, through observations from a different perspective."

Piet van Kampen
Co-owner and Commercial Director of DGI
The Netherlands

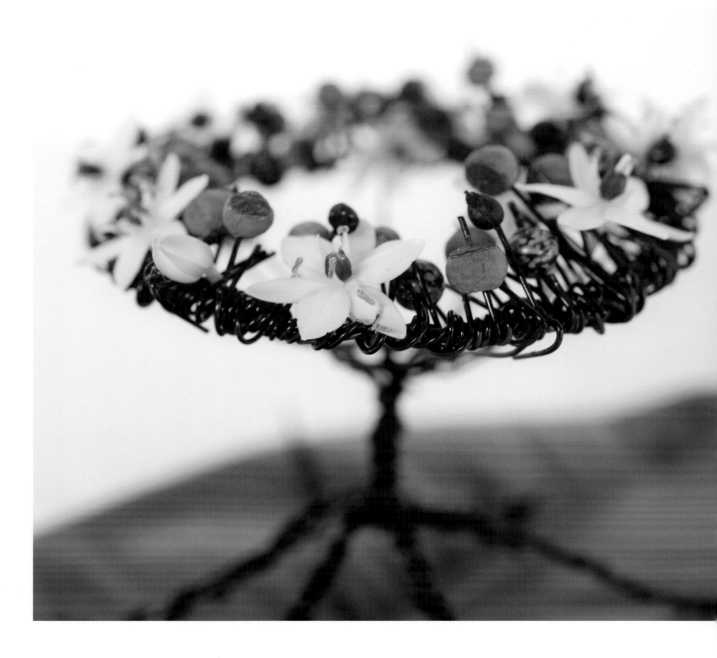

JULIE PEARSON NDSF, AFIOPF, GCGC

[UNITED KINGDOM]

Julie is a professional florist and owner of Global Interiors in Bolton, England. She is a teacher and demonstrator who plays and experiments with incredible flora and accessories.

Photography by: Julie Pearson NDSF, AFIOPF, GCGC

"Whilst appreciating the aesthetic and beauty of floral materials, I encourage students to listen to what the flowers are saying! Think about the emotion, methodology, culture and technique behind the design. Taking inspiration from nature and art, I like to incorporate other crafts such as woodworking, paint techniques and sewing into my work."

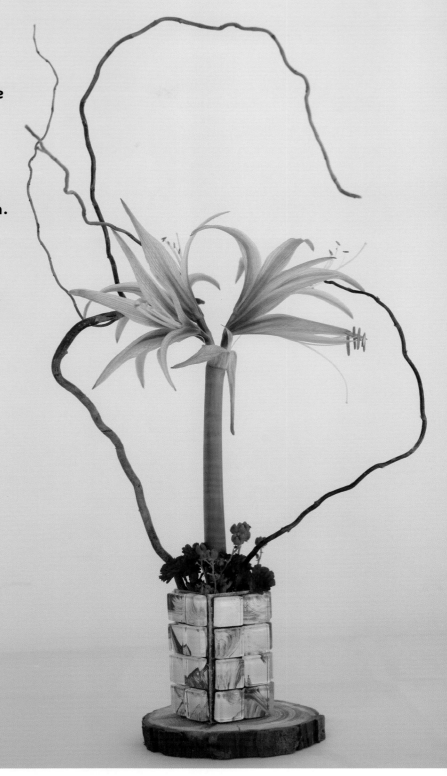

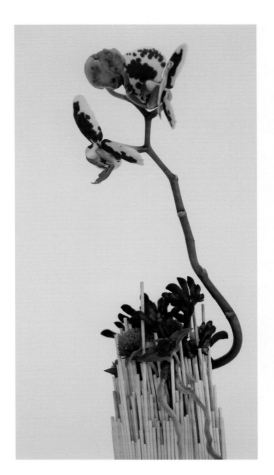

TECHNIQUE TIP:

With the corrugated cardboard design, the concept is to create
a recycled design by taking waste along with something of value,
like a vessel for flowers. By creating a container with dynamic
angles and using cut stipes of discarded cardboard, at varying
depths to ensure the gradual edge, this creates an aesthetic
gives actual support to the structure.

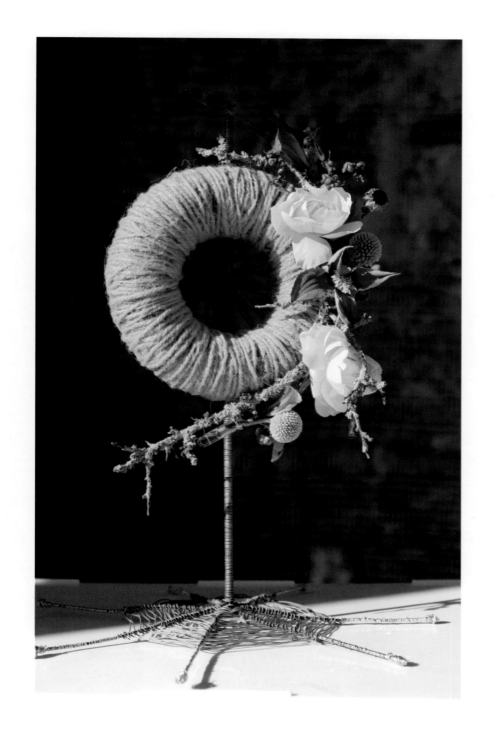

JULIE PEARSON NDSF, AFIOPF, GCGC

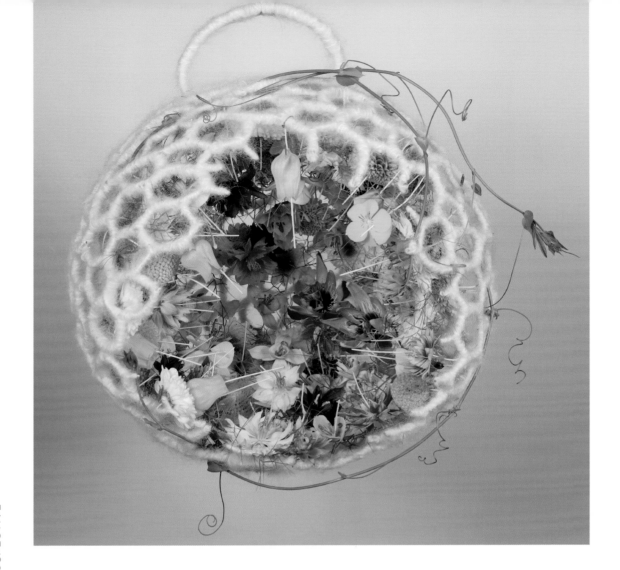

"Driven by detail and precision, I love to incorporate natural and allied crafts and in my designs. My creative world revolves around what I discover through the world of science and physics. Literally, my creative world is inspired through the 'eye of a microscope.'"

AGNA MAERTENS EMC [BELGIUM]

A chemistry, physics and biology teacher turned floral artist, Agna is a freelance florist based in Beermen, Belgium. She has been in the industry for five years and has a great passion for floral teaching.

Photography by: Agna Maertens EMC and Jorge Uribe AIFD, CFD, EMC

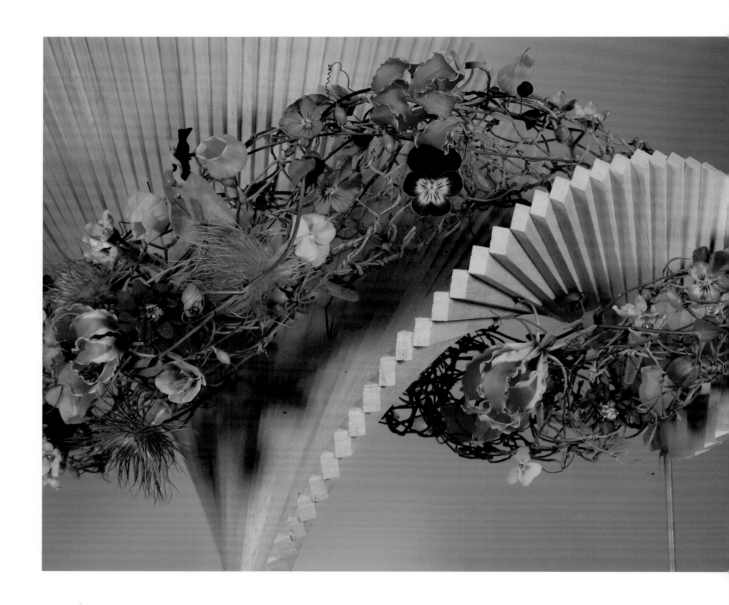

TECHNIQUE TIP:
The spiral wood arrangement is constructed by cutting pieces of wood into desired lengths. Cut a hole in each piece where a solid rod can be inserted. String the pieces onto the rod. This will allow for this piece to collapse into a flat, transportable and reusable construction.

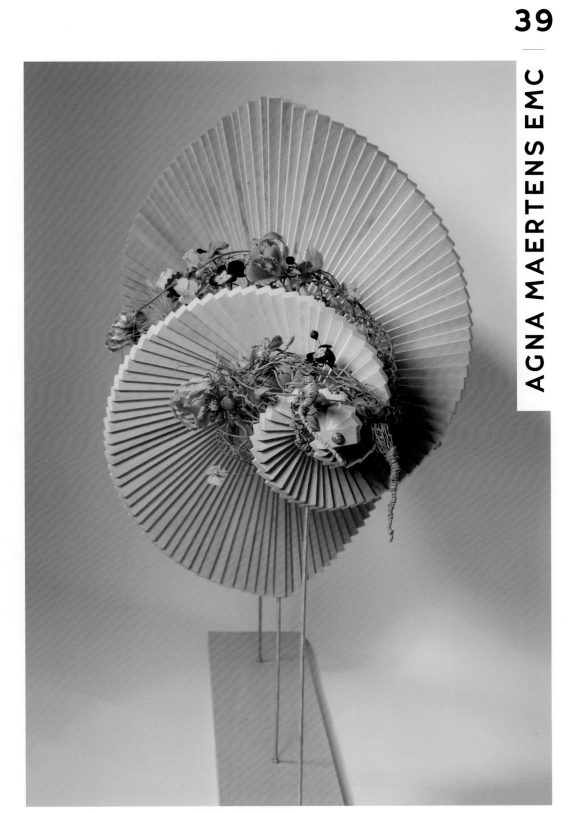

TECHNIQUE TIP:
With the wax plate design, the focus is designing within a color palette. Wax creates an interesting matte texture that emphasizes the colors and the beauty of the flowers. It is the perfect material to use in a winter- time arrangement.

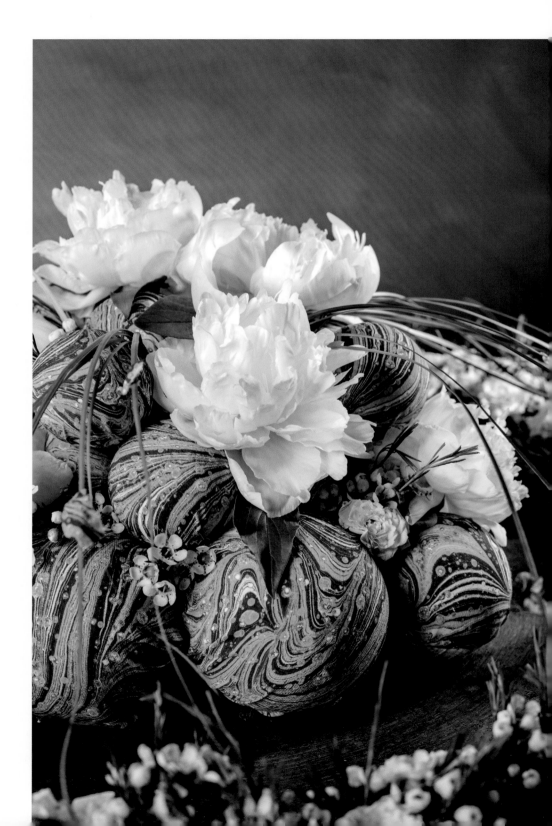

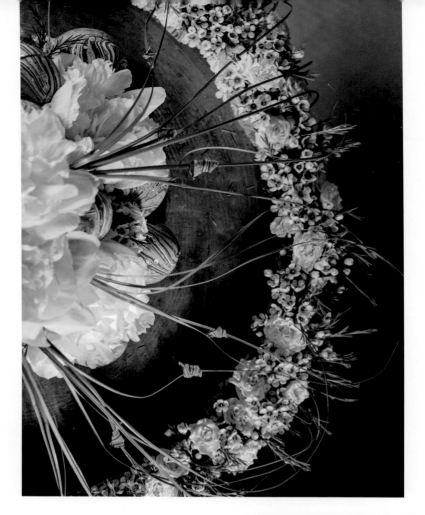

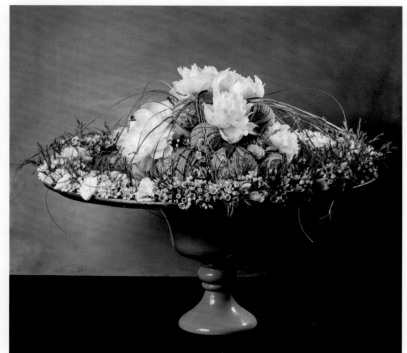

TUBA BELGIN OSKAN EMC

[TURKEY]

An Istanbul-based floral designer, Tuba has been creating floral wonders in her studio, Natura Karmasince, since 2014. Originally a professional in destination and event management, she discovered her creative side while searching for a more emotionally satisfying career.

Photography by: Nurdan Usta and Irem Tanman

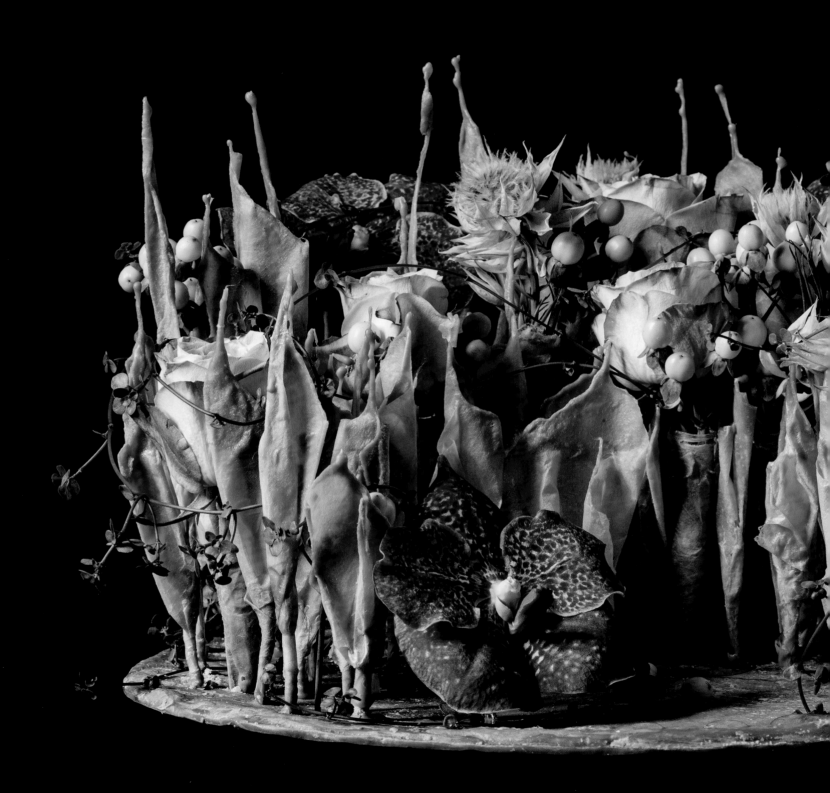

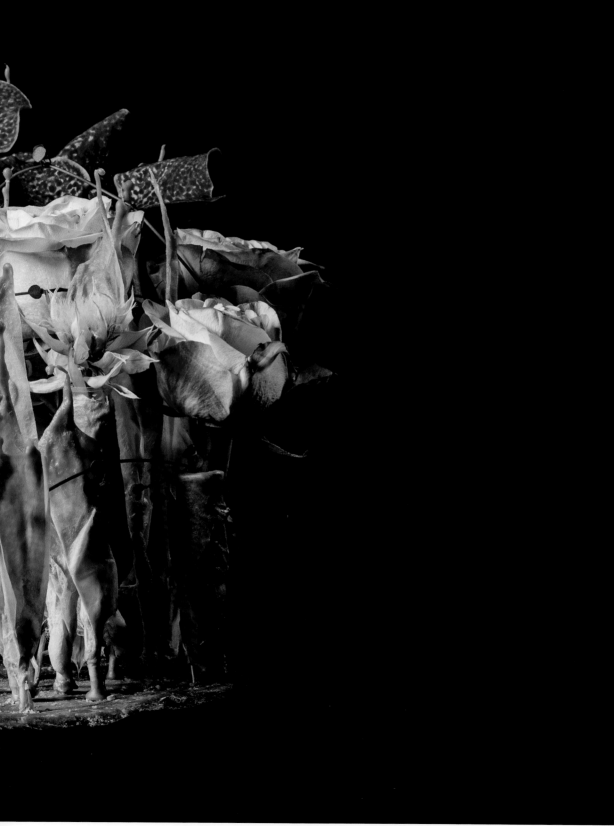

TUBA BELGIN OSKAN EMC

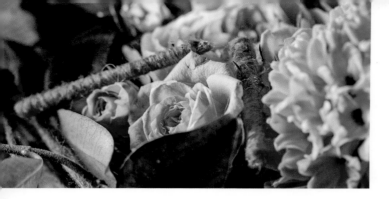

"I inherited the love of art and nature from my mother, whom I lost when I was only ten years old. Creating with flowers allows me to form a spiritual connection with her. I am also able to share joy through creativity with friends, family and clients."

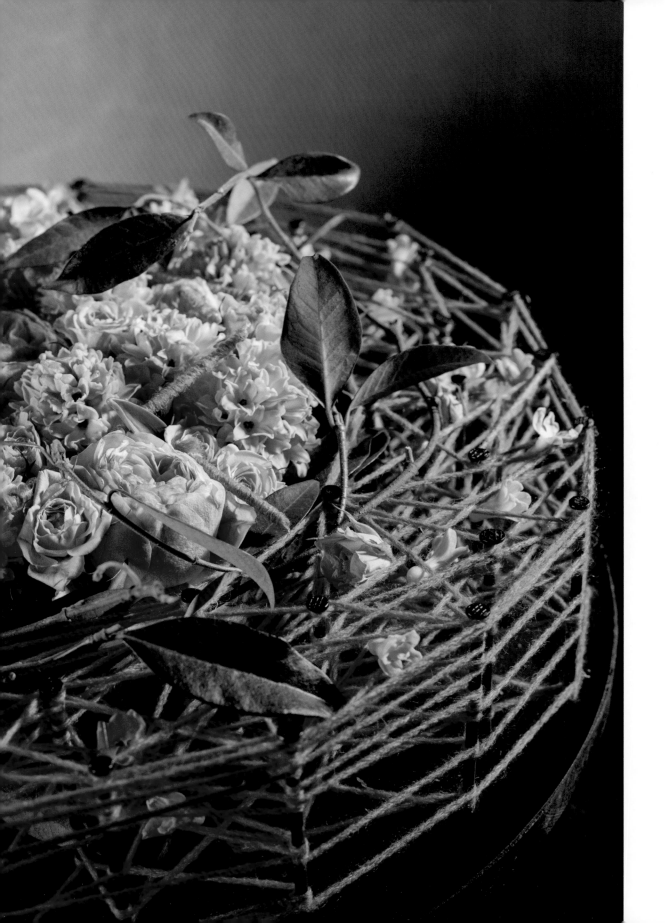

TUBA BELGIN OSKAN EMC

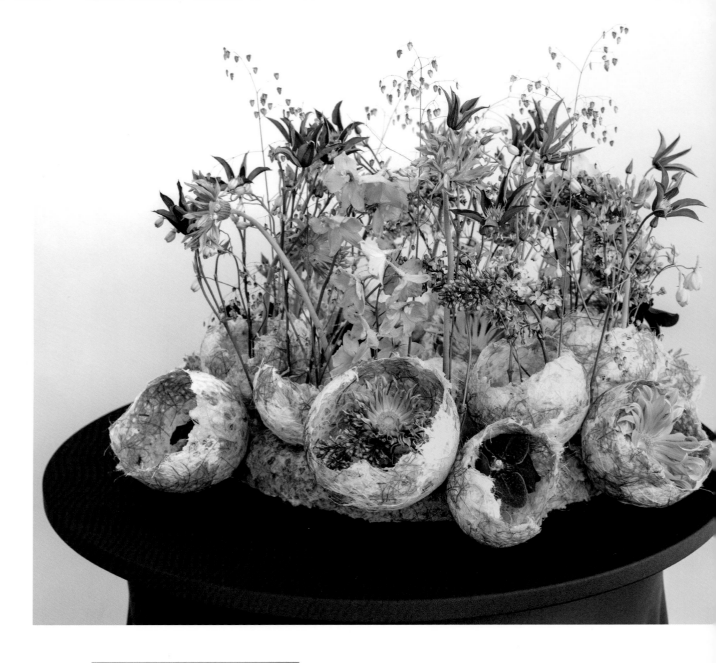

TOMASZ MAX KUCZYŃSKI

[POLAND]

As a young man of 16, Tomasz completed his first floral course and knew instantly flowers would be the major part of his private and professional life. Ever since completing his studies in fine arts and interior decoration, he has been competing and giving courses, workshops and demonstrations around the world. Tomasz owns Florysty Agency in Krakow, Poland, where he specializes in weddings and corporate contracts.

Photography by: JJens Poulsen, Blomster

TECHNIQUE TIP:
Just be yourself!!! Try to find your own inspiration everywhere! Keep your eyes and heart open.

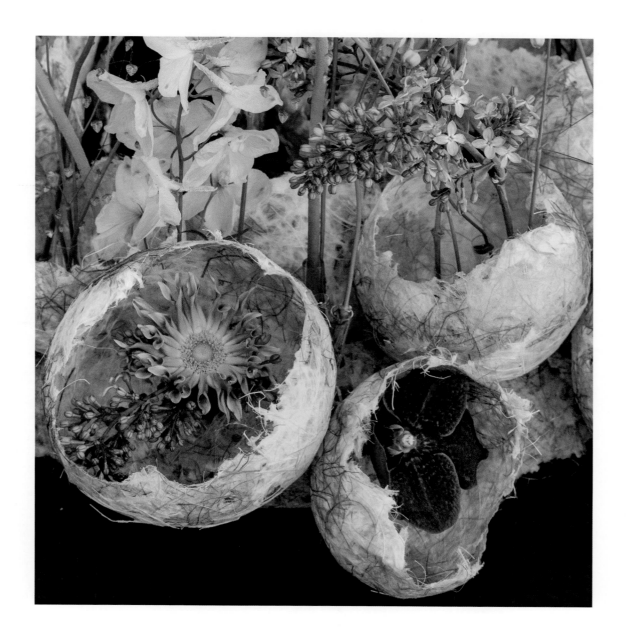

TOMASZ MAX KUCZYŃSKI

"When I was **18**, I attended a Gregor Lersch workshop. I still get inspired by his works. I admire him for his excellent technique, beautiful forms and the fact that he keeps shocking us again and again. I am inspired by many florists. I like to watch interesting forms, color combinations, new techniques but I never copy. I am searching for my own way and want to present my own vision of floristry."

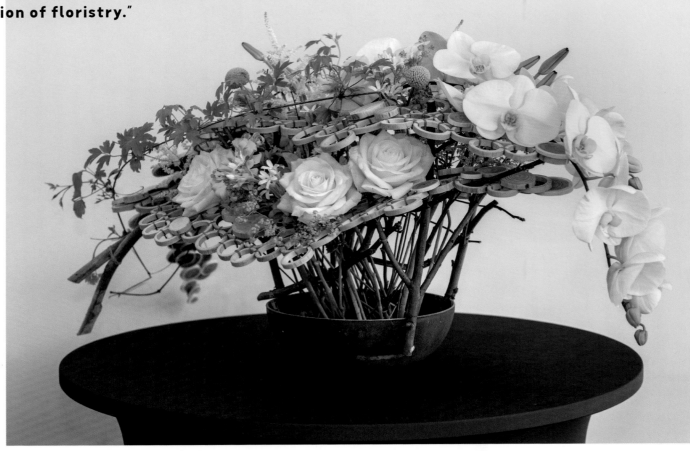

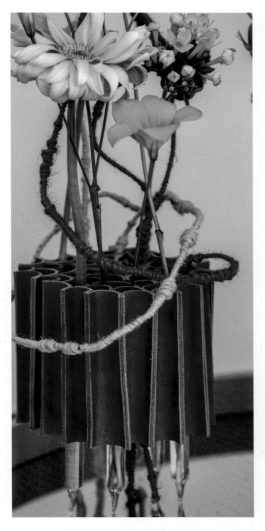
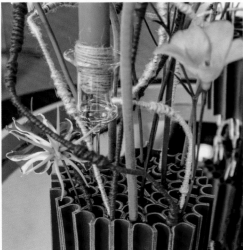
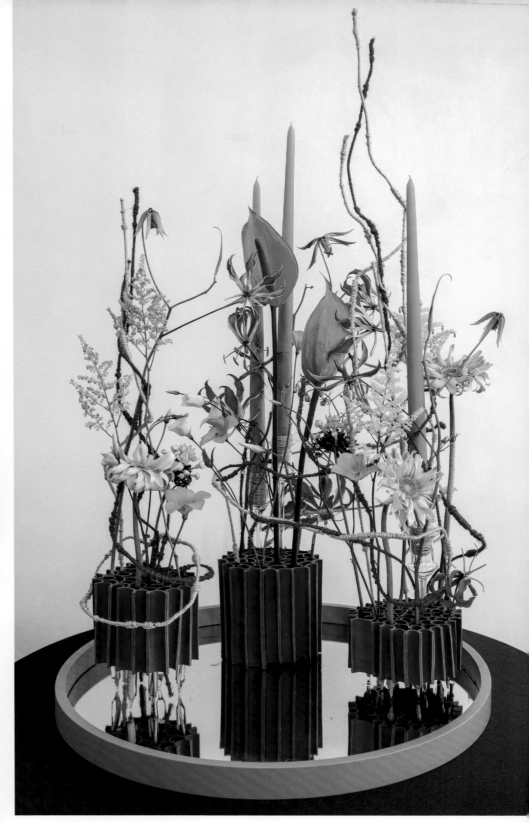

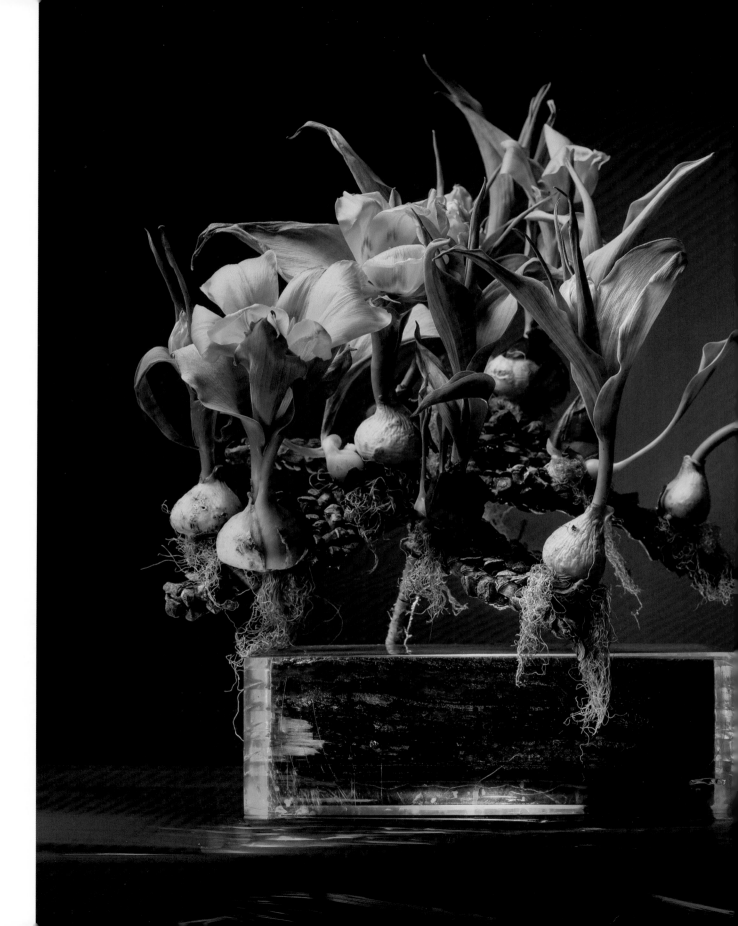

CREATIVITY: A GLOBAL FLORAL INTROSPECTIVE

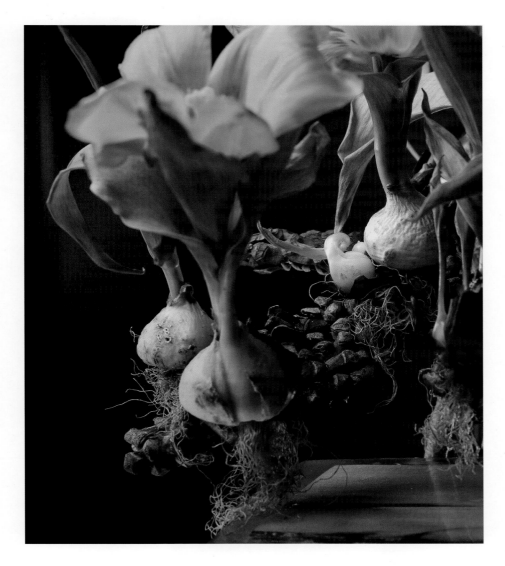

DIANA TOMA EMC [ROMANIA]

After working in the corporate world of the Telecom industry, Diana decided to listen to her creative side and started her own floral studio, in Timisoara, Romania. She is floral artist and educator.

Photography by: Diana Bilec

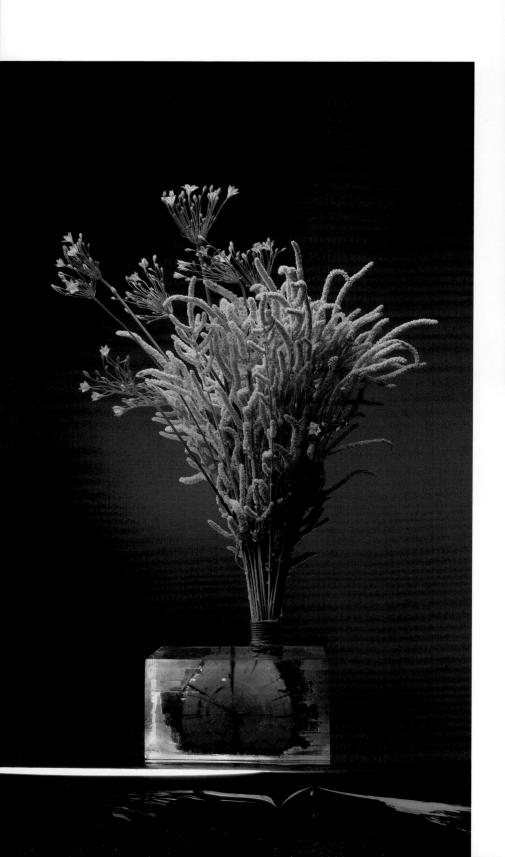

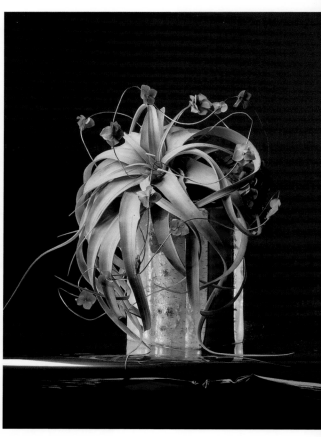

TECHNIQUE TIP:
All designs are constructed
on a support, handmade from
a piece of wood encapsulated
in an epoxy resin cube. The
flower choice and the shape
of the design are adapted to
represent the four elements
of nature: Earth, Wind, Fire
and Water. The Earth is
implied through its absence;
the Air with the use of
Amaranthus albus, awaiting
a windy breeze; Fire implied
with the shape and color of
the materials; and the Water
by the wavy lines of just the
right botanical.

"Romania, my home, is a country that offers a spectacular, unique natural landscape filled with wildlife and beautiful virgin forests. As a child, and due to those years spent close to the wilderness, the pure beauty of nature is deeply anchored in my creative being and create vegetative representations."

DIANA TOMA EMC

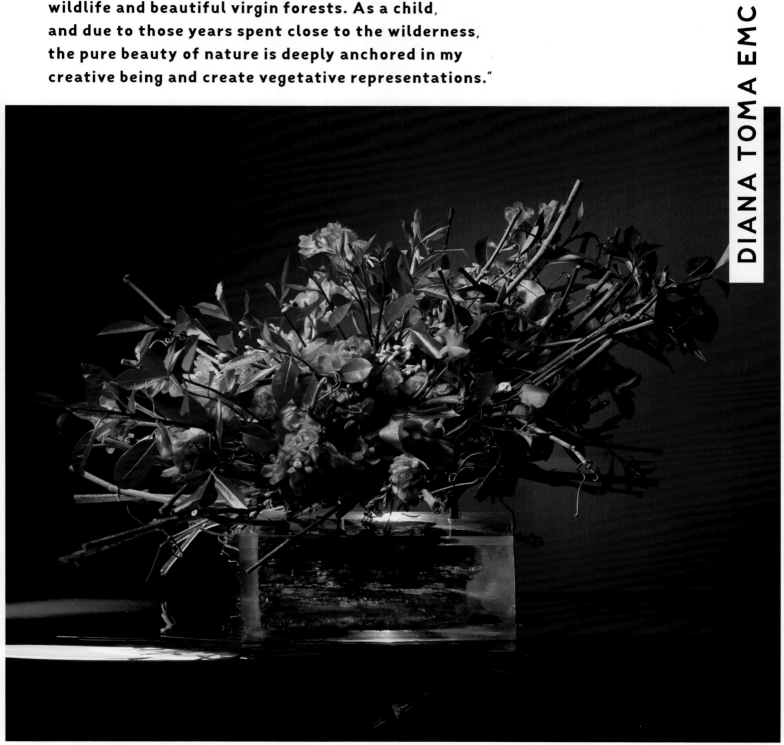

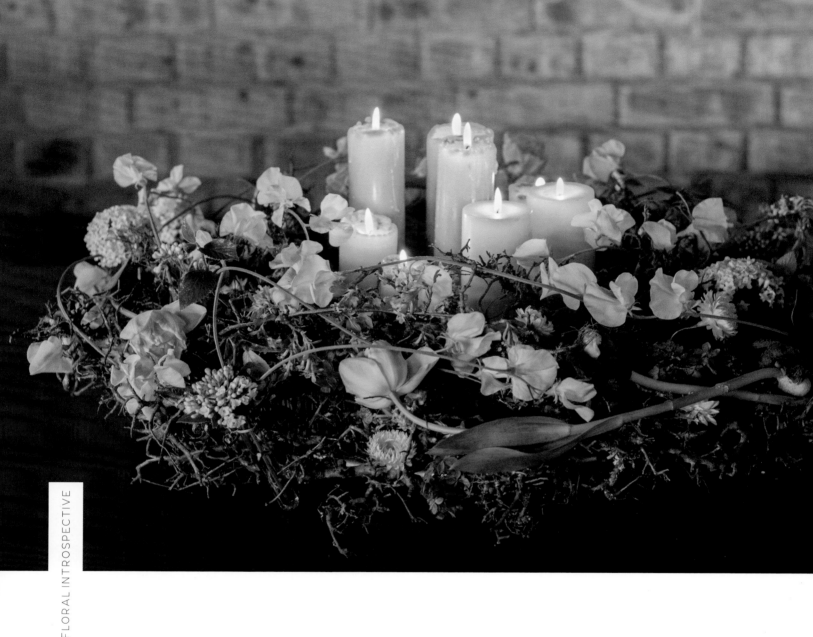

SARA-LISA LUDVIGSSON [SWEDEN]

A freelance designer, Sara-Lisa has been in the floral industry since she was 16 years old. Owner of Sara-Lisa Flowers and Friends in Karlstad, Sweden, she is an educator and inspirer who travels the world teaching and presenting.

Photography by: Amanda Lennartsson

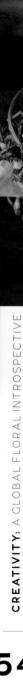

"I love to meet other people who are interested in flowers. I am inspired by them. It is also important to be inspired by things other than flowers. For example, being inspired by a walk in the forest, a visit to a museum, or attending a concert. Creativity is hard work, but I have noticed that the more time I spend at it, the easier it is to be creative."

SARA-LISA LUDVIGSSON

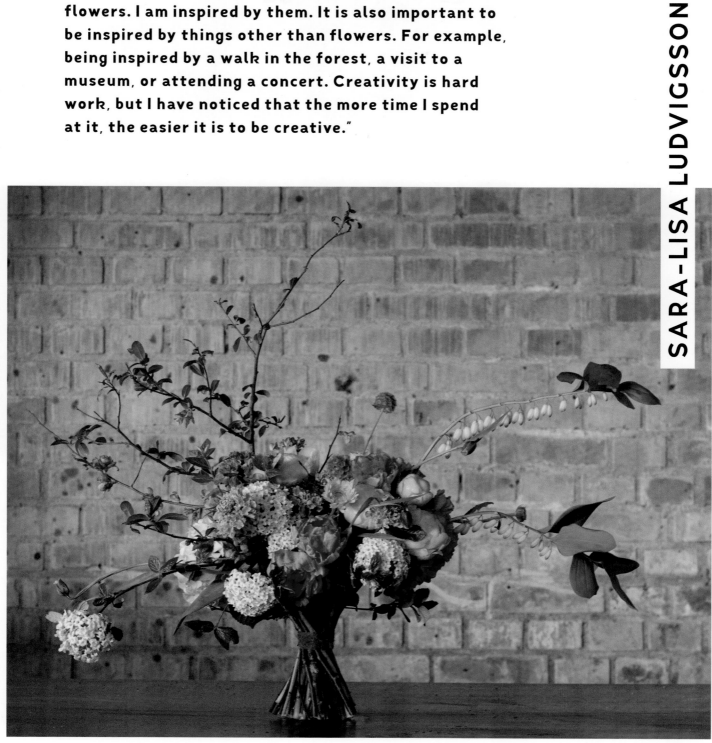

TECHNIQUE TIP:
I love to suggest working with what we call in Sweden "slug tape" or snail tape. It is found in garden centers and is made from copper. It attaches easily to other materials and gives a visual impact by creating a strong line. The tape is also twistable. In general, it breaks easily but if you wrap it around floral wire, it becomes very strong.

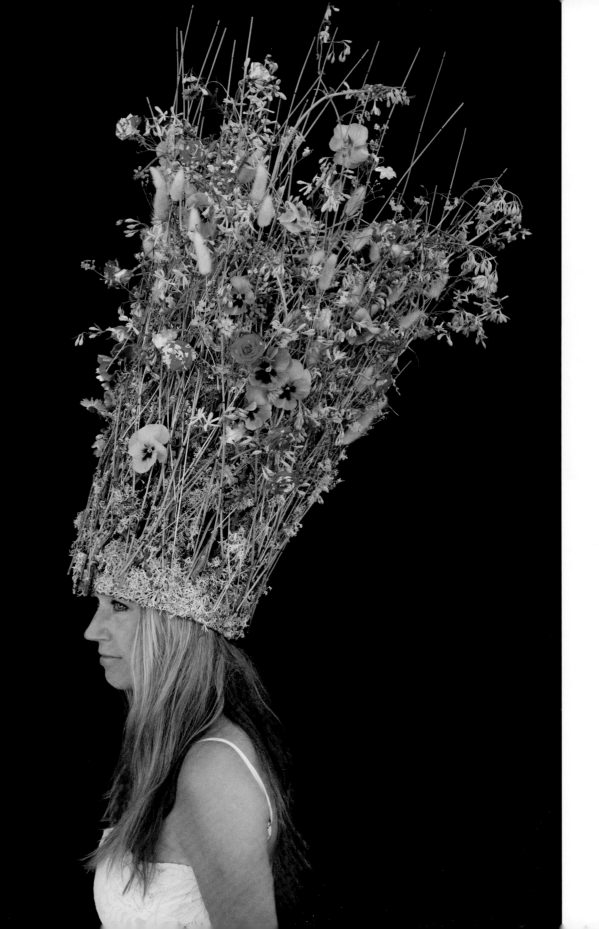

GEA KORPEL-BESKERS

[THE NETHERLANDS]

A freelance florist from Roosendaal, The Netherlands, Gea creates organic objects from different kinds of materials such as wool, cotton and ceramics. Her passion for combining textiles and flowers is exhibited in her floral art.

Photography by: Mike van der Weegen, Anne-Riet Vugts and Gea Korpel-Beskers

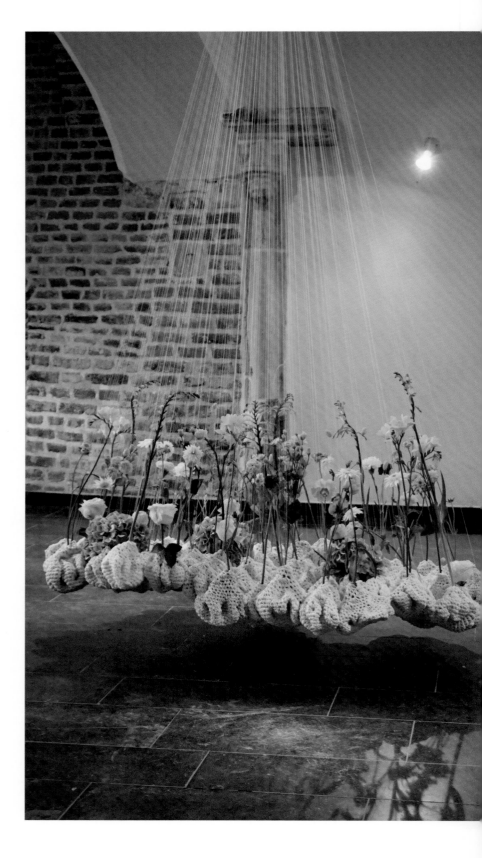

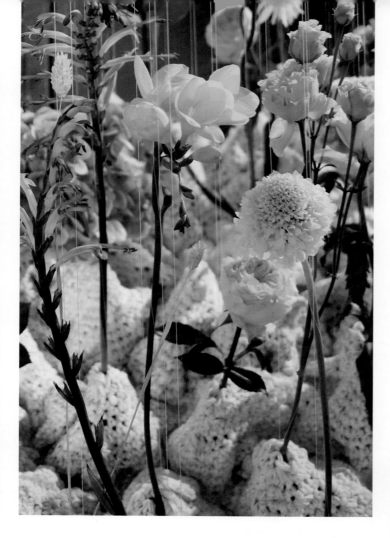

TECHNIQUE TIP:
Choose something unexpected by combining different materials. Step out of your comfort zone and don't be afraid to make mistakes. I always find the most amazing combinations when trying something I have never done before. Also keep it simple, less is more. That's what I always keep in mind when creating my objects.

"I find inspiration in nature, in details and in structures. I like to use mostly second-hand materials. I don't see the point in buying new materials when there is so much out there already. Many people have materials in their attic waiting to become something beautiful. Most of the time it feels like my materials find me and they tell me what they want to become."

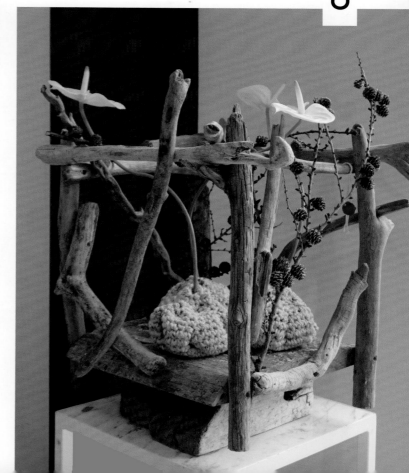

"One looks outside for inspiration... creativity comes from within. True creativity is one that is spontaneous!"

Deborah De La Flor AIFD, CFD, PFCI
Owner De La Flor Florist & Gardens,
Cooper City, Florida

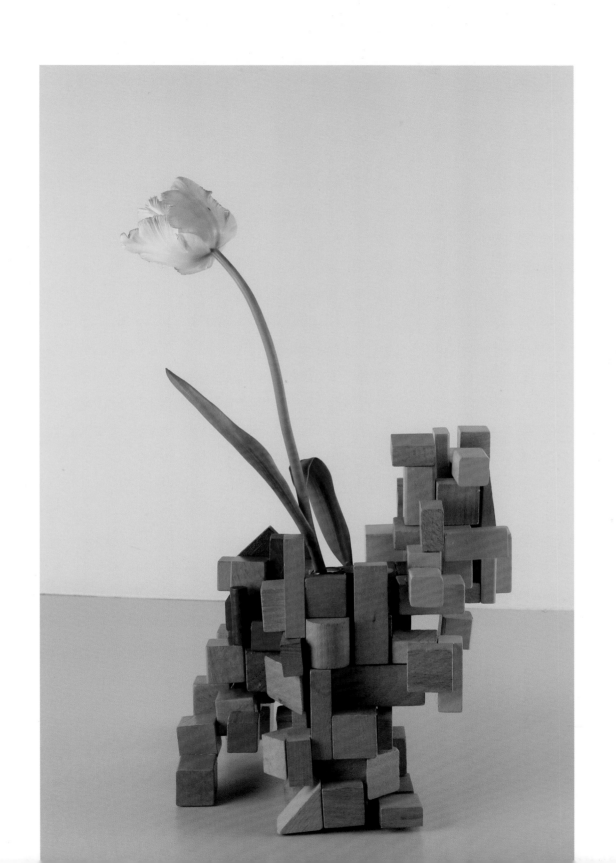

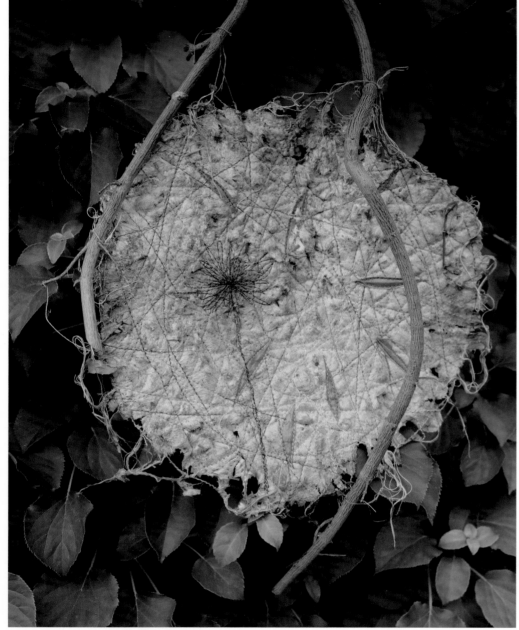

TECHNIQUE TIP:
When constructing a
floral composition, the
materials you use do
not need be expensive
Use leftovers or costless
materials and use them
in an unusual way. It will
give tension. It will make
it interesting. It doesn't
have to be perfect.

YVONNE SCHEENLOOP TERLOUW

[THE NETHERLANDS]

A professional florist based in Dordrecht, The Netherlands,
Yvonne has been inspired since birth to experiment with
organic and abstract visual art. She works primarily with
materials directly from nature or organic waste materials.

*Photography by: Annemarijne Bax, Roos van Unen,
Yvonne Terlouw*

"Who I am and the art I make are part of a larger whole, therefore, I deeply trust the process of creation. Everything is in connection with the Universe. Freedom to me is finding an appropriate and ultimate combination of expression, material and techniques for each project. To handle nature with care is important to me. The beauty and the possibilities of natural materials you will see harmoniously reflected throughout my art."

YVONNE SCHEENLOOP TERLOUW

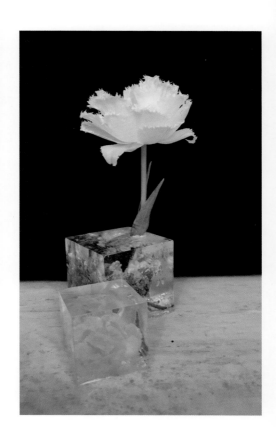

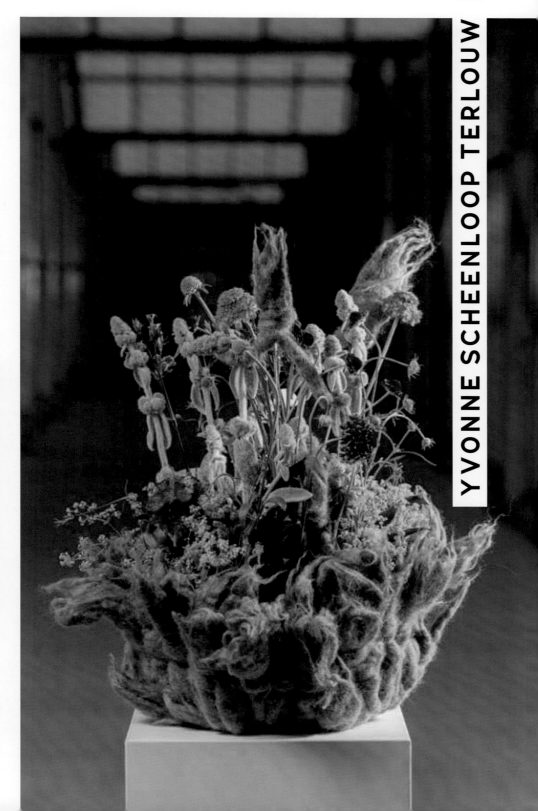

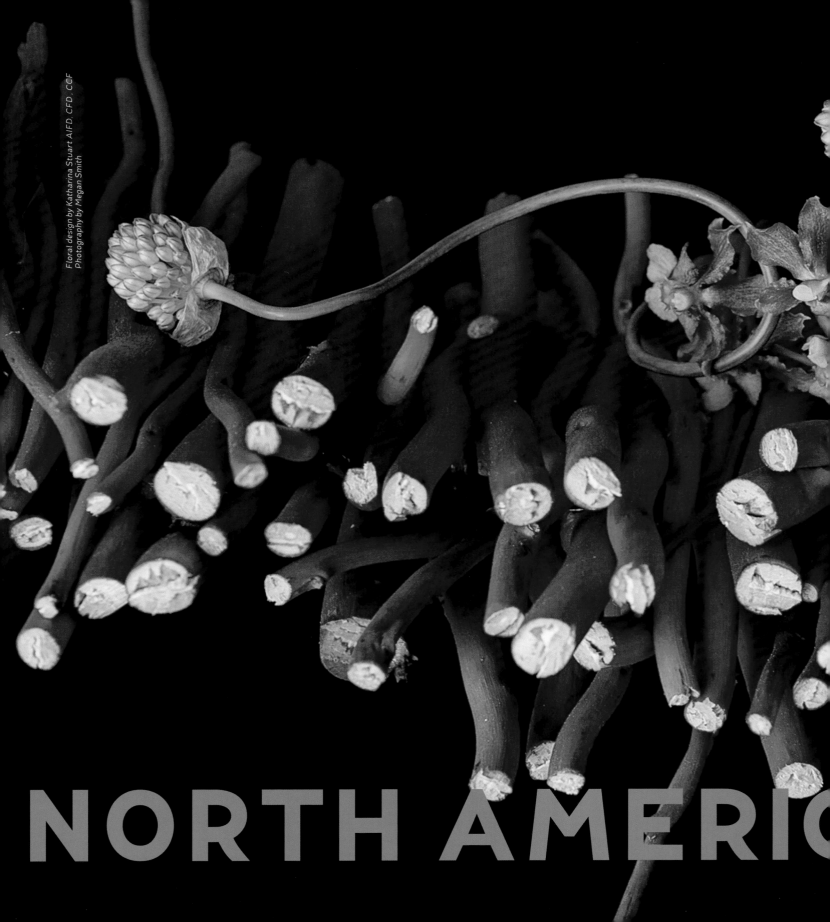

Floral design by Katharina Stuart AIFD, CFD, CCF
Photography by Megan Smith

NORTH AMERIC

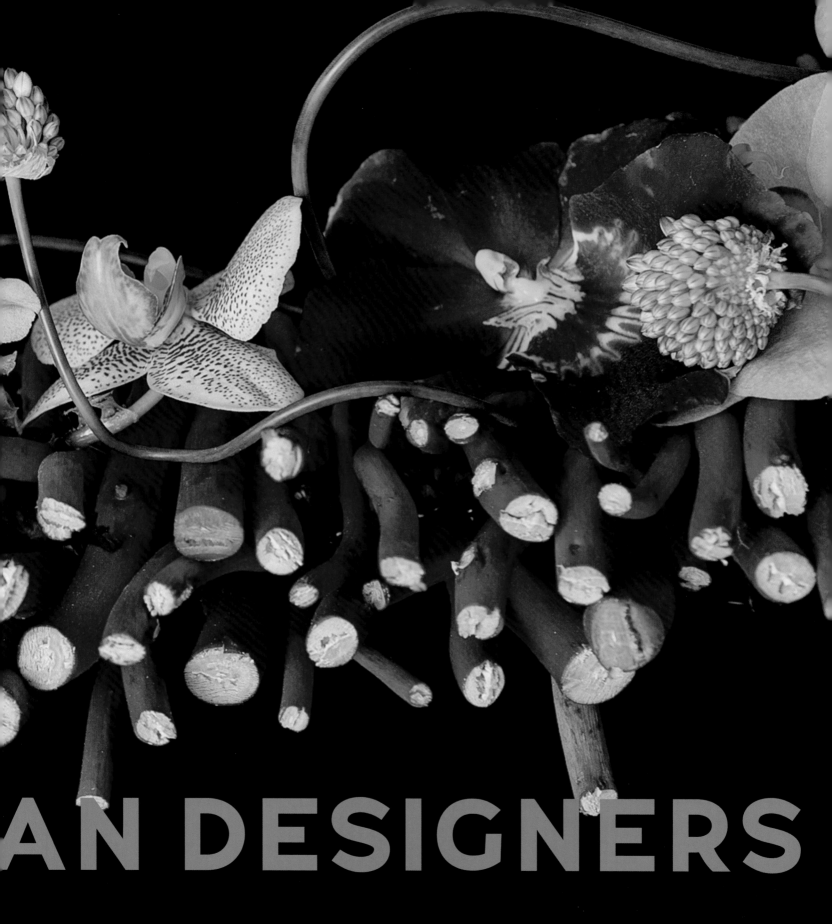

AN DESIGNERS

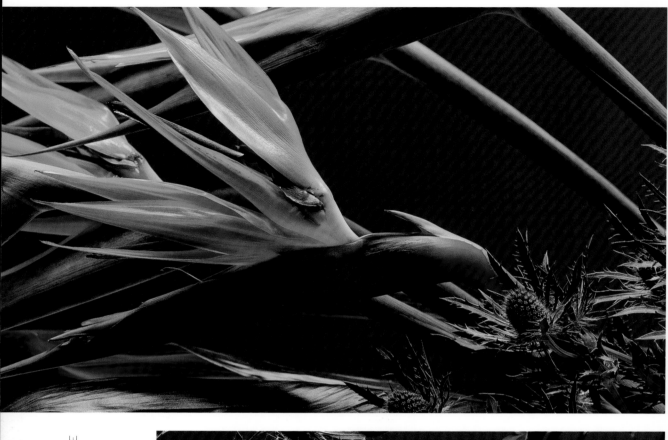

66

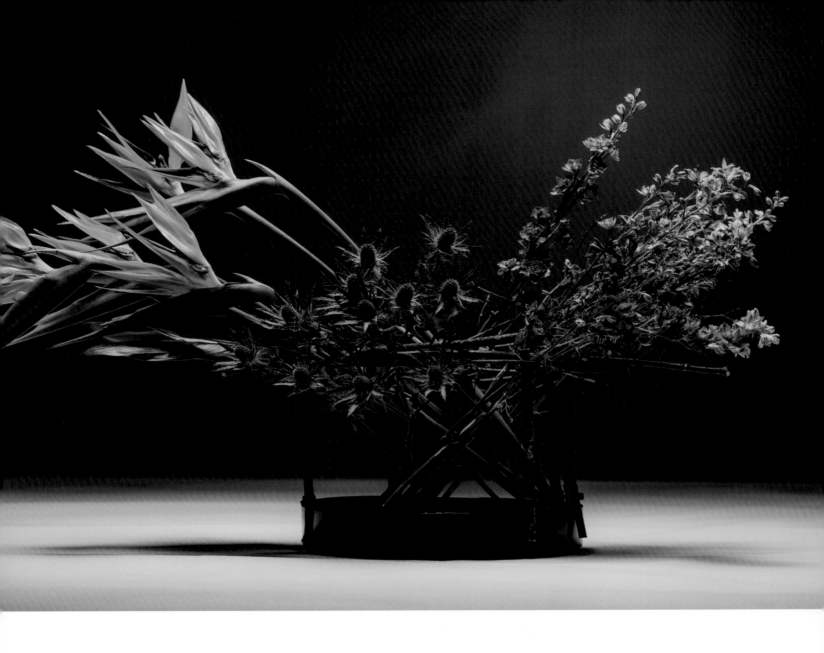

SUSANNE LAW AIFD, CFD, EMC [CANADA]

An educator and floral artist for over 20 years, Susanne is the head designer at La Belle Fleur Floral Boutique in Surrey, British Columbia, Canada. She enjoys challenging herself with new pursuits such as competitions and creative design projects.

Photography by: Colin Gilliam Photography and Design

"I believe creativity is in each and every one of us. It's when you have the courage to release it that your mind gets excited. But more important it's when you embrace it, the creativity fulfills your soul."

Joyce Mason-Monheim AIFD, CFD, AAF, PFCI, AzMF
Owner Designer Destination
Tucson, Arizona

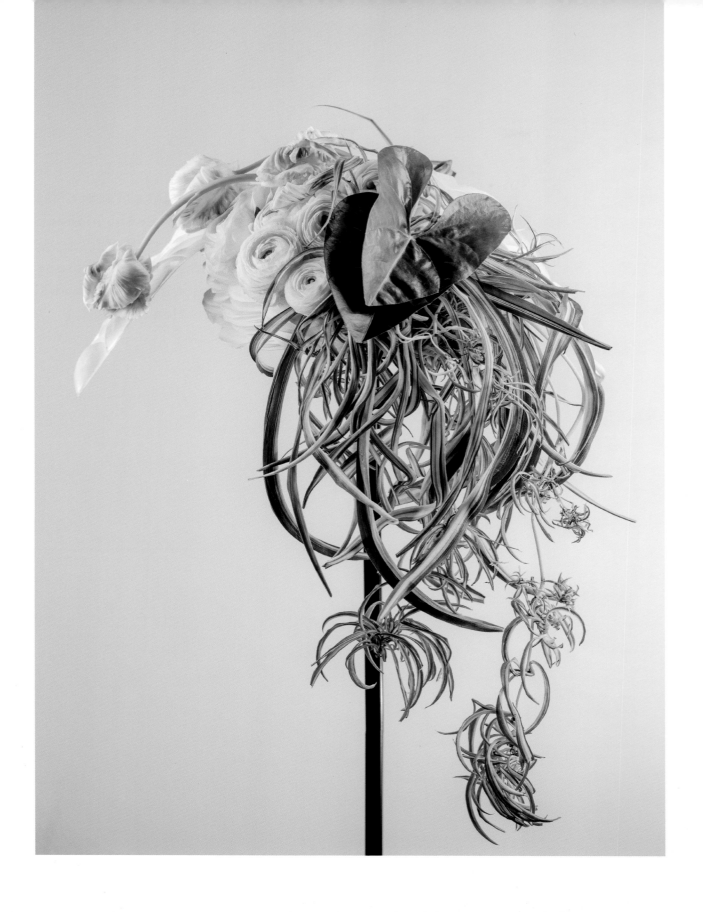

SUSANNE LAW AIFD, CFD, EMC

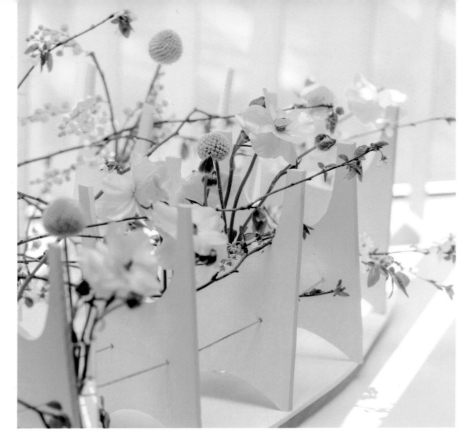

"To replicate Mother Nature is to give her the highest compliment. Nature teaches us many valuable lessons and provides us with endless inspiration."

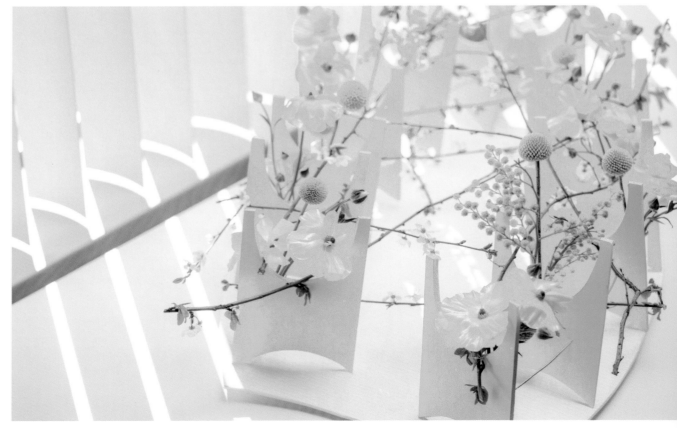

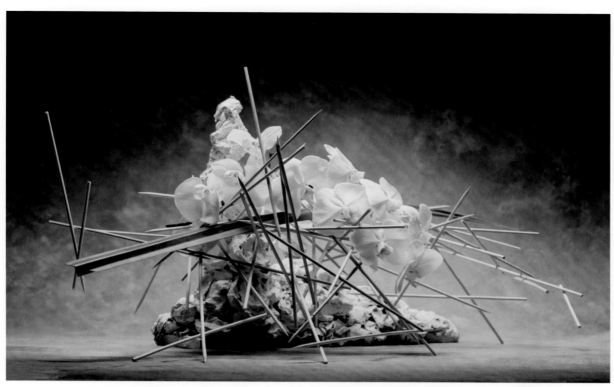

SUSANNE LAW AIFD, CFD, EMC

TECHNIQUE TIP:
With the design of the white *Phalaenopsis*, a successful construction requires a good foundation, support materials and an x-factor. It is a symbiotic relationship, one depending on the other. In this case, the plaster structure is the foundation to support the exoskeleton of skewers. The *Phalaenopsis* orchids, the x-factor, add the finishing touch.

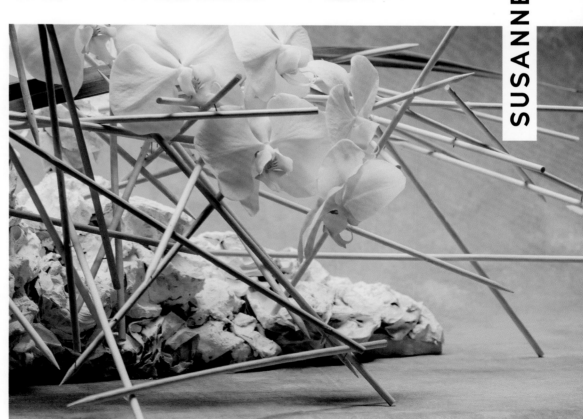

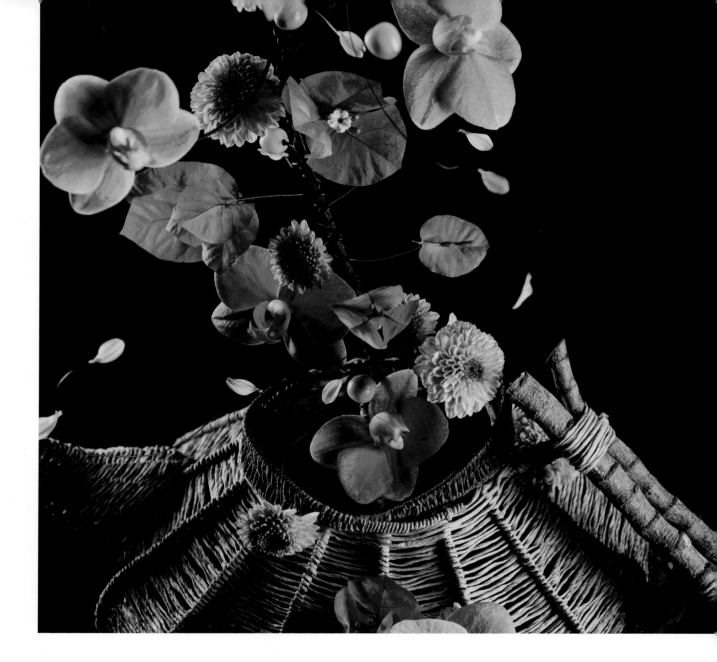

BRENNA QUAN AIFD, CFD
[CANADA]

As a professional dancer and choreographer, Brenna's foundation as an artist began with the study of lines and movement from a young age. Freelancer and owner of Brenna Quan: Botanical Art in Vancouver, Canada, her natural prowess for emotional expression eventually transitioned into the art of floral design. She travels teaching and producing floral art exhibits.

Photography by: Colin Gilliam Photography and Design

TECHNIQUE TIP:
On this woven teapot design, wire of all types allow the ability to create a form that can be a direct image transported from the imagination! This assemblance of a teapot began as a stem of gathered straight wires and a spool of paper covered wire to become a sculpted vessel for the emergence of a rising mist of individual petals and blooms. The vibrant color story hints at a comforting cup of tea to warm the soul.

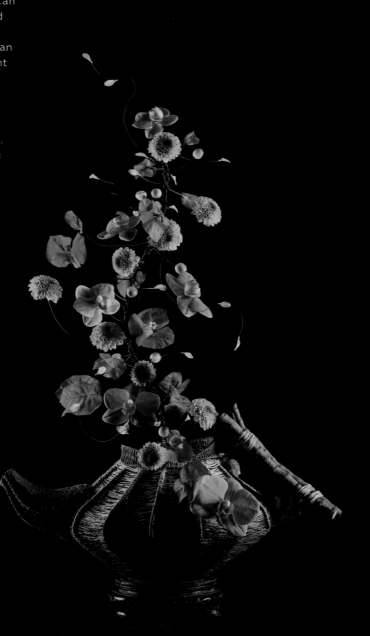

BRENNA QUAN AIFD, CFD

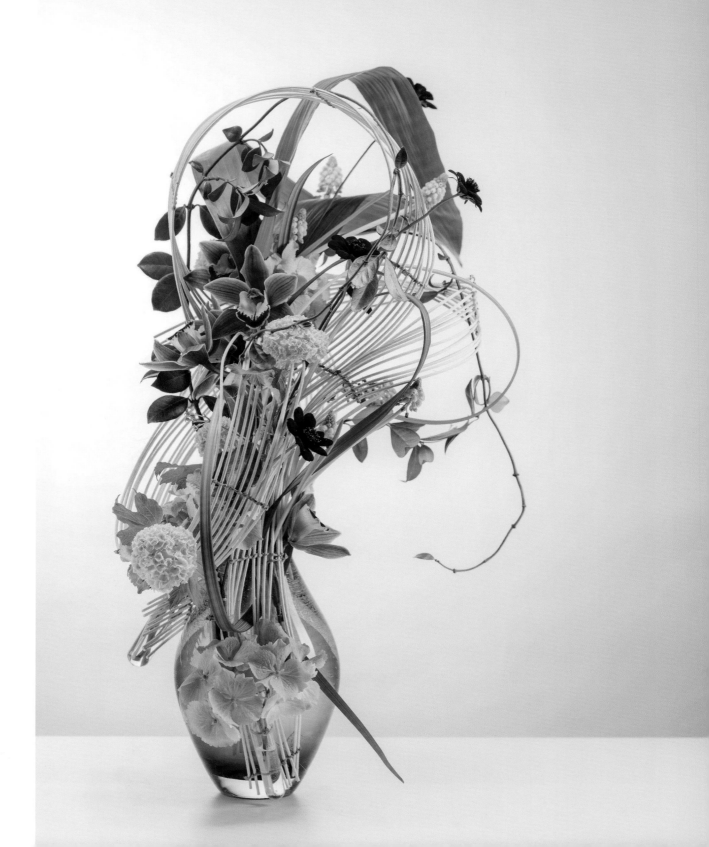

"I find that the flicker of inspiration can begin with a random material or found object and then exploring its potential to become part of a dynamic visual design. The process that develops involves conceptualizing and then experimenting with various techniques to stretch beyond the obvious choice. My belief is that the existence of creativity is inherent in everyone in some form or another. I love the freedom of us being able to act upon it anywhere, anytime within our imaginations!"

BRENNA QUAN AIFD, CFD

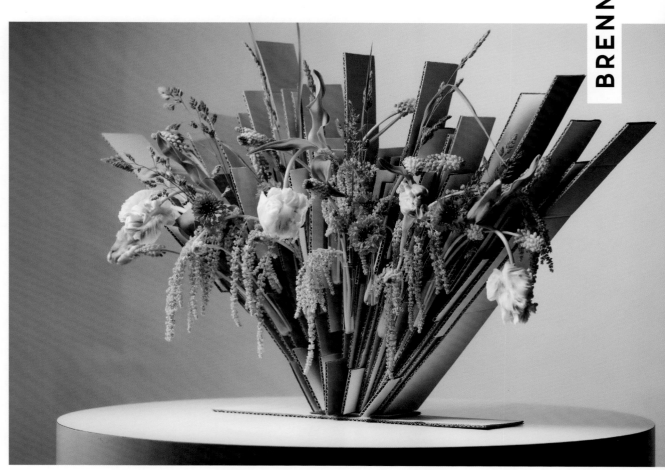

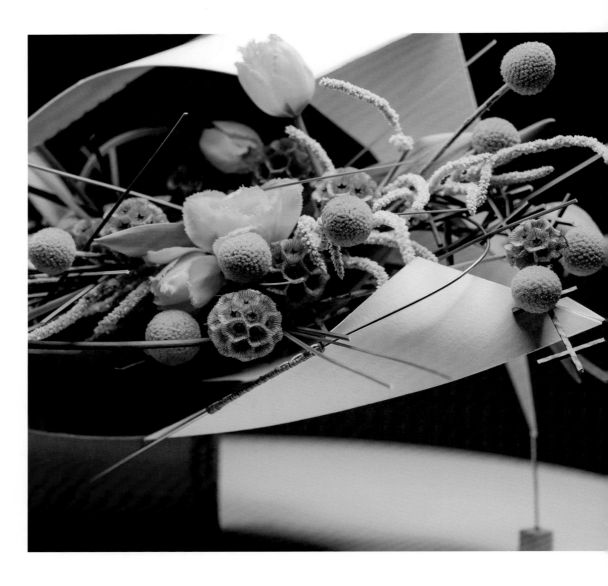

76

PAUL JARAS AIFD, CFD [CANADA]

An architectural illustrator who was trained and educated as an architectural draftsman with a background in Architectural Technology, Fine Arts and Fashion Design, Paul's floral art marries the analytical as well as artistic sides of design. He is a floral artist and floral teacher from Kamloops, British Columbia, Canada.

Photography by: Colin Gilliam Photography and Design

"The contrast of the man-made components and
botanical materials within a structural composition
exemplifies my work, which is often influenced and
inspired by relationships of line, space and form in
architecture and geometry."

PAUL JARAS AIFD, CFD

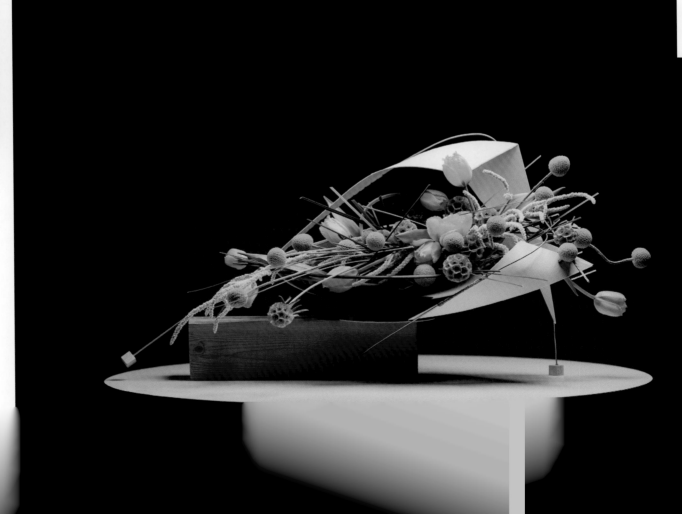

TECHNIQUE TIP:
I created structures based on a series of three, hinged wooden triangles which twisted as they spanned opposite sides of a parabolic arch made of steel round bar. The method was adapted for these designs by creating triangles of heavy-weight watercolor paper carefully stitched with paper-covered wire to arches made of galvanized steel wire. The resulting planes appear to float in space as they frame and shelter the floral materials.

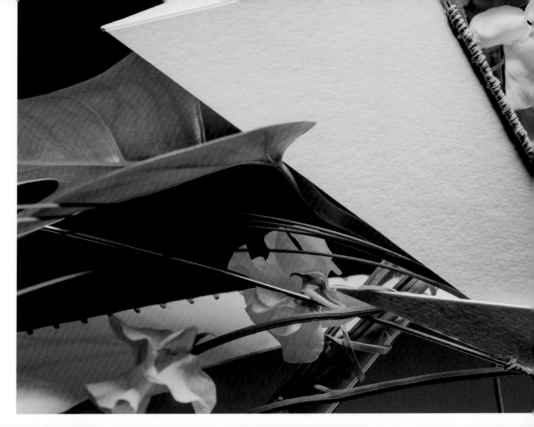

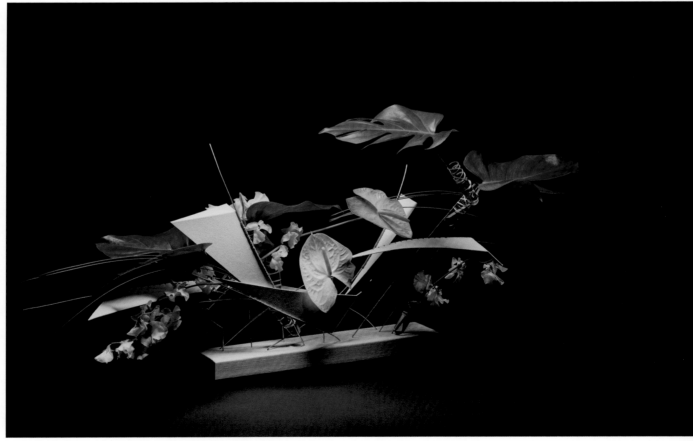

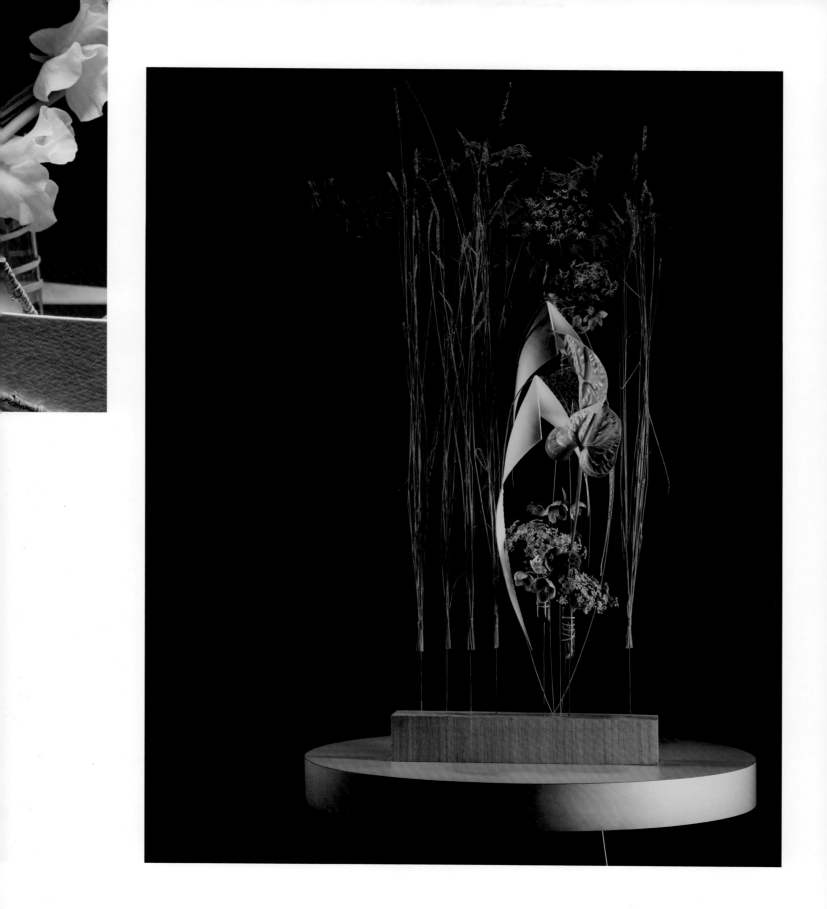

TECHNIQUE TIP:
Be your own greatest fan. Create in
a style that excites you for that will
provide you an endless source for
inspiration and motivation.

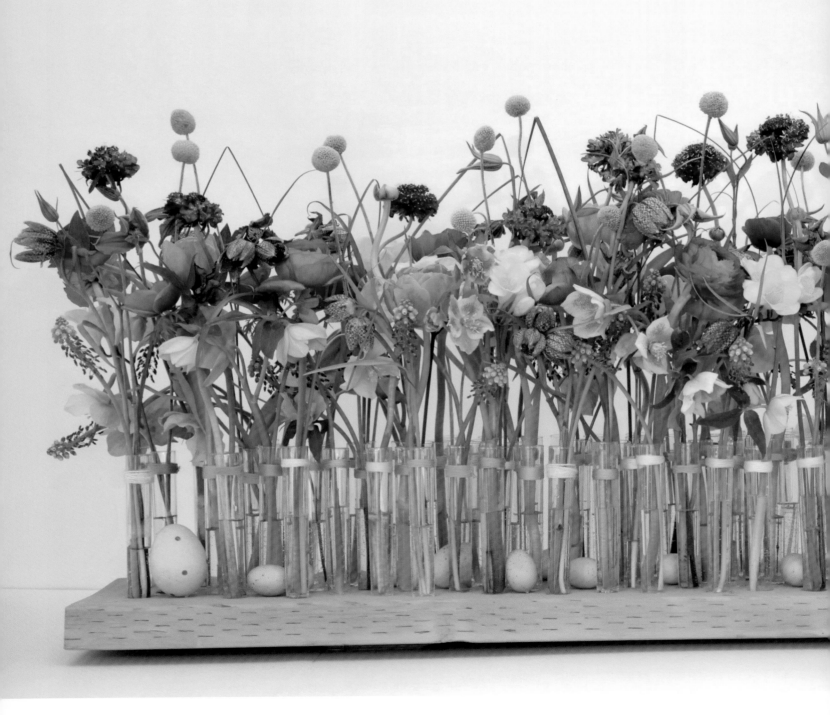

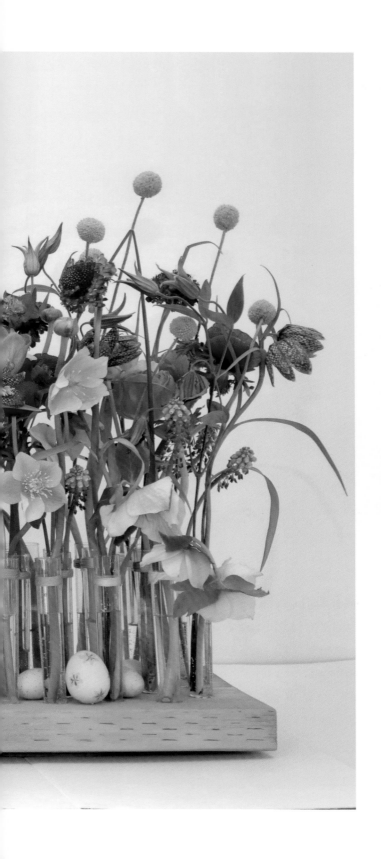

DALIA BORTOLOTTI EMC

DALIA BORTOLOTTI EMC [CANADA]

After a career change from the telecommunication industry in 2002, Dalia discovered her true calling within the floral world. A freelance designer and educator from Ottawa, Canada, she travels the world educating florists.

Photography by: Dalia Bortolotti EMC

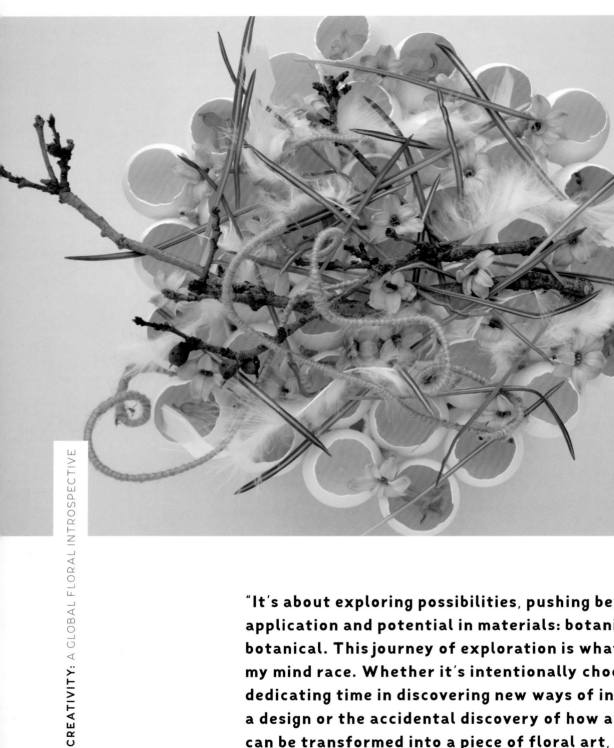

"It's about exploring possibilities, pushing beyond the obvious application and potential in materials: botanical and non-botanical. This journey of exploration is what drives me, makes my mind race. Whether it's intentionally choosing a material, dedicating time in discovering new ways of incorporating it into a design or the accidental discovery of how an everyday item can be transformed into a piece of floral art, this journey is what inspires me and nourishes my appetite to learn."

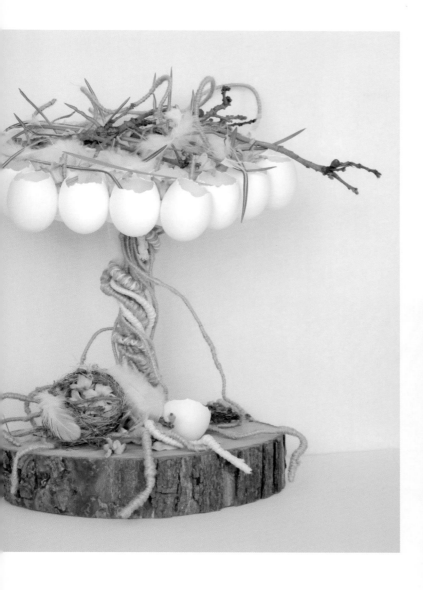

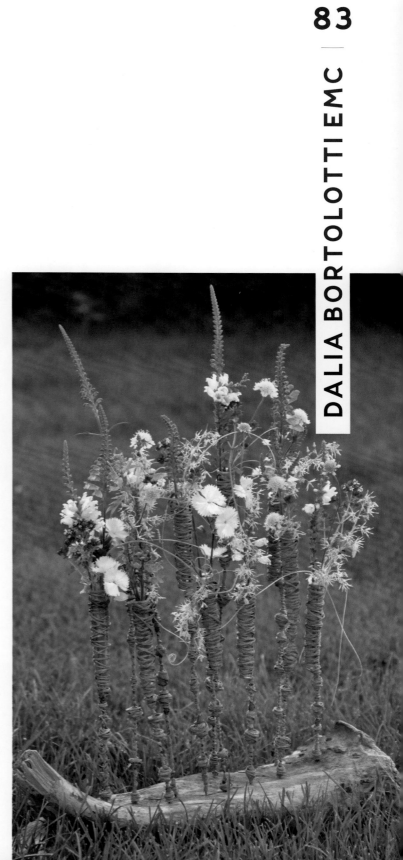

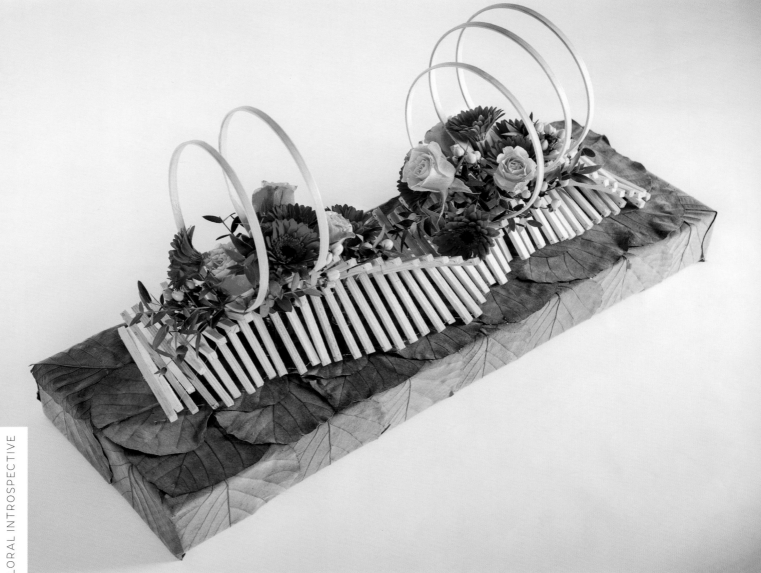

84

EDITH GUZMÁN DÍAZ EMC [MEXICO]

A political sociologist, Edith spent the first part of her career working in the political realm. In 2003, she discovered floral art and since dedicated herself completely to the study and work in floral design. She is the owner of Edith Guzmán Designs, Floral Art Gallery, Mexico City, Mexico.

Photography by: Edith Guzmán Díaz EMC, Santiago Amo, Alberto Leal

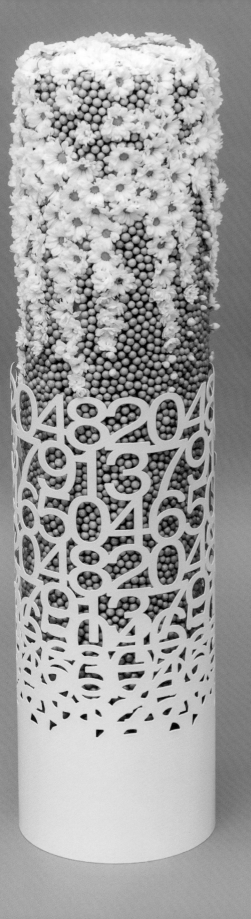

EDITH GUZMÁN DÍAZ EMC

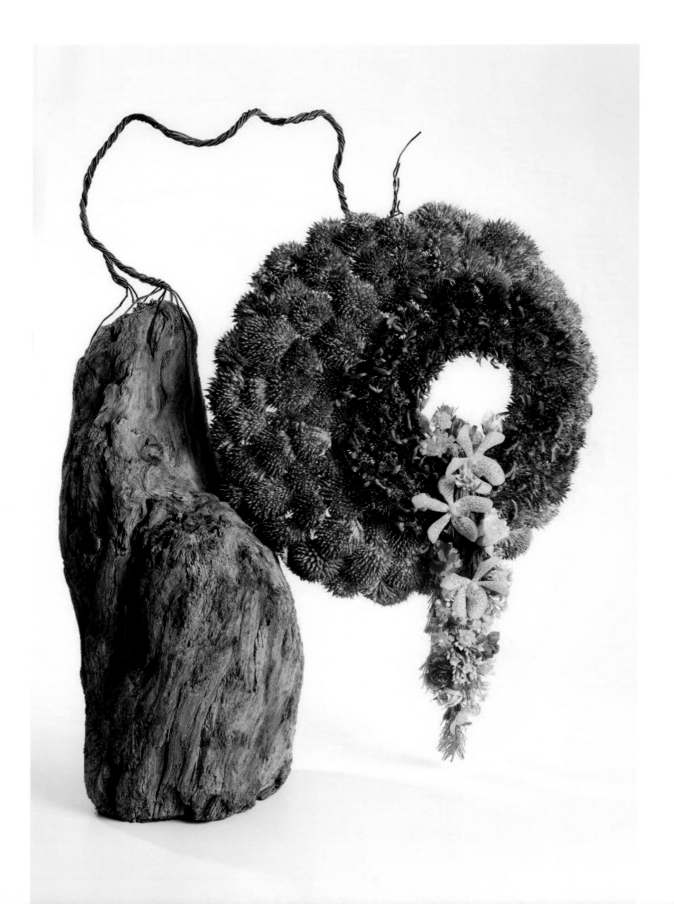

"What inspires me?
Nature and life. I am a great
observer of what surrounds me.
There are many things, objects,
shapes, colors that attract me.
I try to capture their beauty
and aesthetics and reconstruct
them with fresh and dry plant
materials. My passion for nature
has led me to develop and create
what I love."

Edith Guzmán Díaz EMC
Owner of Edith Guzman Designs, Floral Art Gallery
Mexico City, Mexico

TECHNIQUE TIP:

The butterfly design is created by slicing the *Bauhinia guianensis*. Drill two holes in the center of the slices. Using floral wire, insert the wire into the holes of the slices and then create a mesh using the chicken wire technique until you create a circle. Connect the tails of the wire to one side of the wooden loop; tuck in the remaining wires back into the composition.

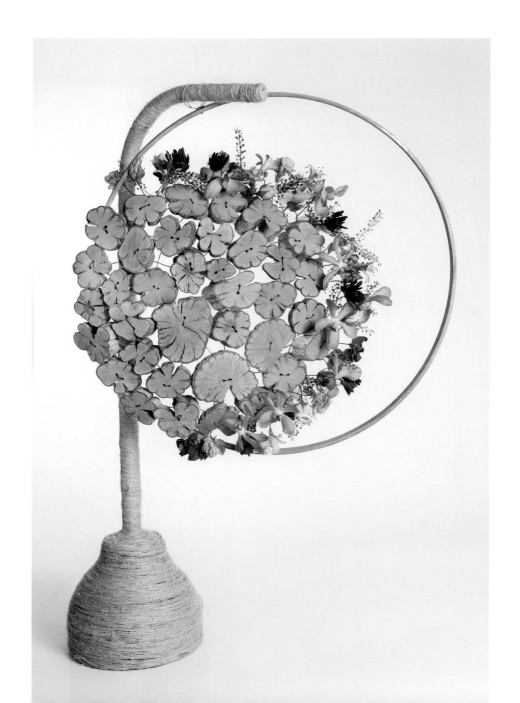

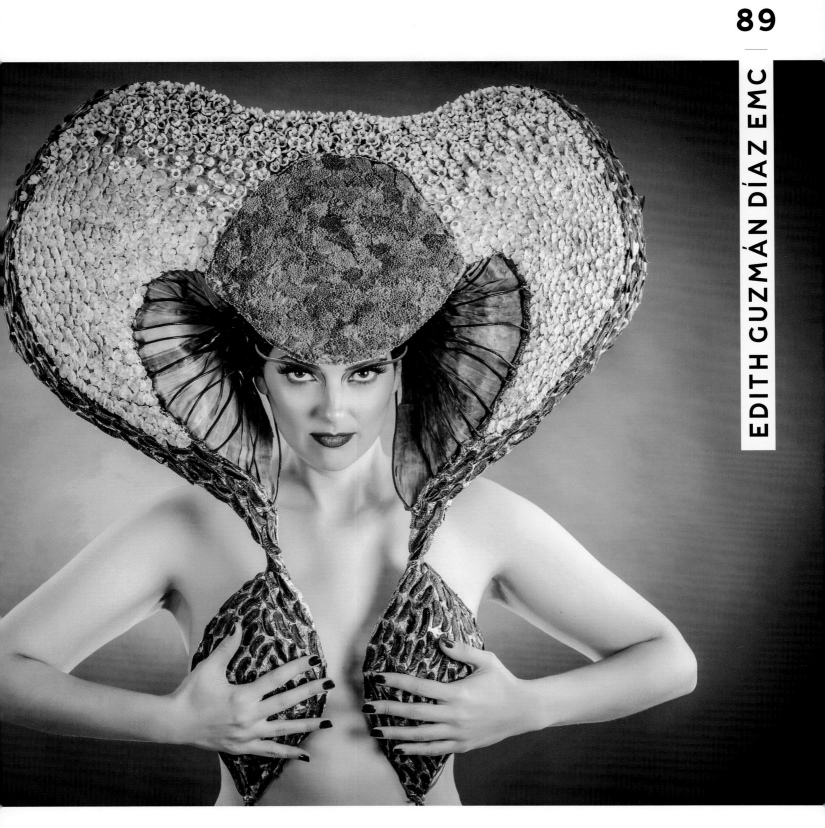

EDITH GUZMÁN DÍAZ EMC

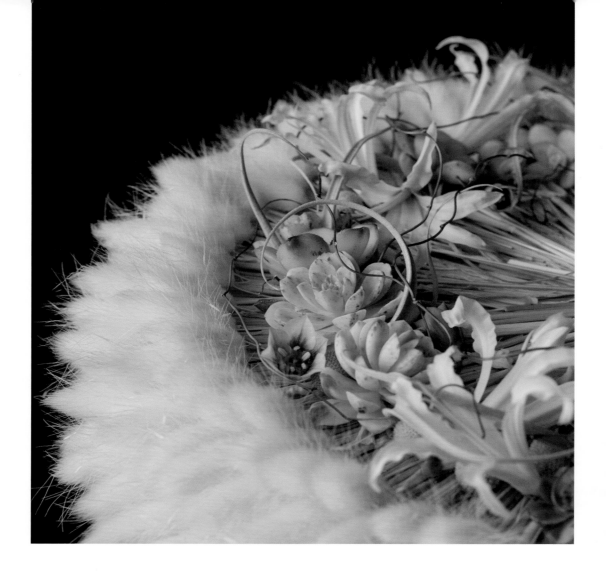

"Inspiration for my work can happen anywhere, at any time, or from any type of material. The process sometimes starts with a material that I'd like to transform. Other times it's a shape I want to create, and often it comes from my affinity with elements in repetition that result in seductive textures. My creative process involves stretching everyday material into a fashion accessory; taking a wreath form to new heights; and playing with textural elements that beg to be touched."

KATHARINA STUART AIFD, CFD , CCF

[U.S.A.]

As a Swiss, third-generation avid gardener, Katharina began exploring the beauties of the natural world and bringing the awe-inspiring beauty of the outdoors into the home. She has been a floral designer for over 30 years and is the owner of Katharina Stuart Floral Art and Design in El Cerrito, California.

Photography by: Megan Smith

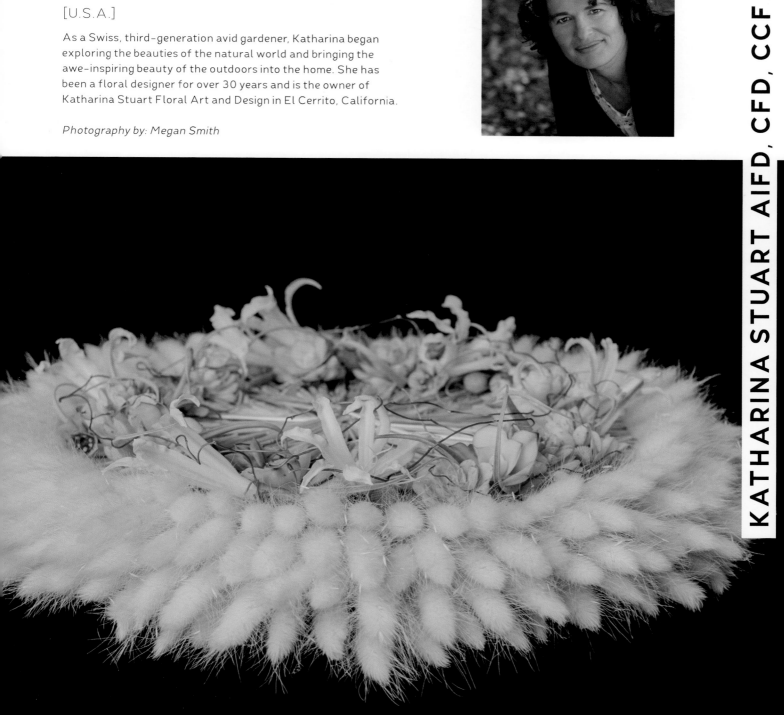

TECHNIQUE TIP:
For this floral chic
accessory, the exterior
surface of the handbag is
created with multiple rubber
bands tied to a wire mesh
structure that has been
shaped into a handbag form.
Finishing touches include
colorful leather bands for
the handles and a vibrant
trim of fresh florals secured
with water tubes placed
inside the bag.

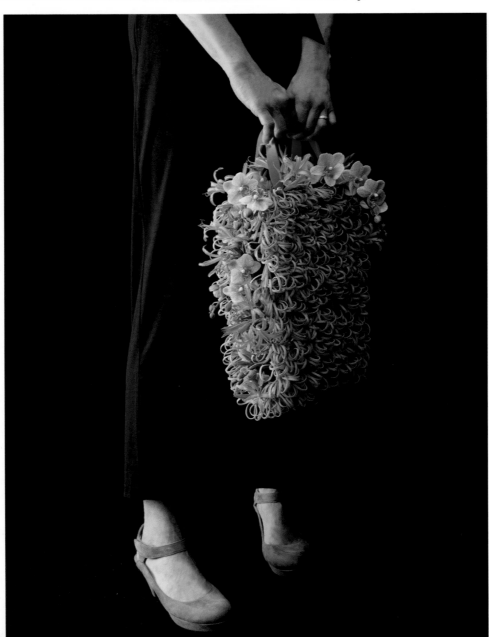

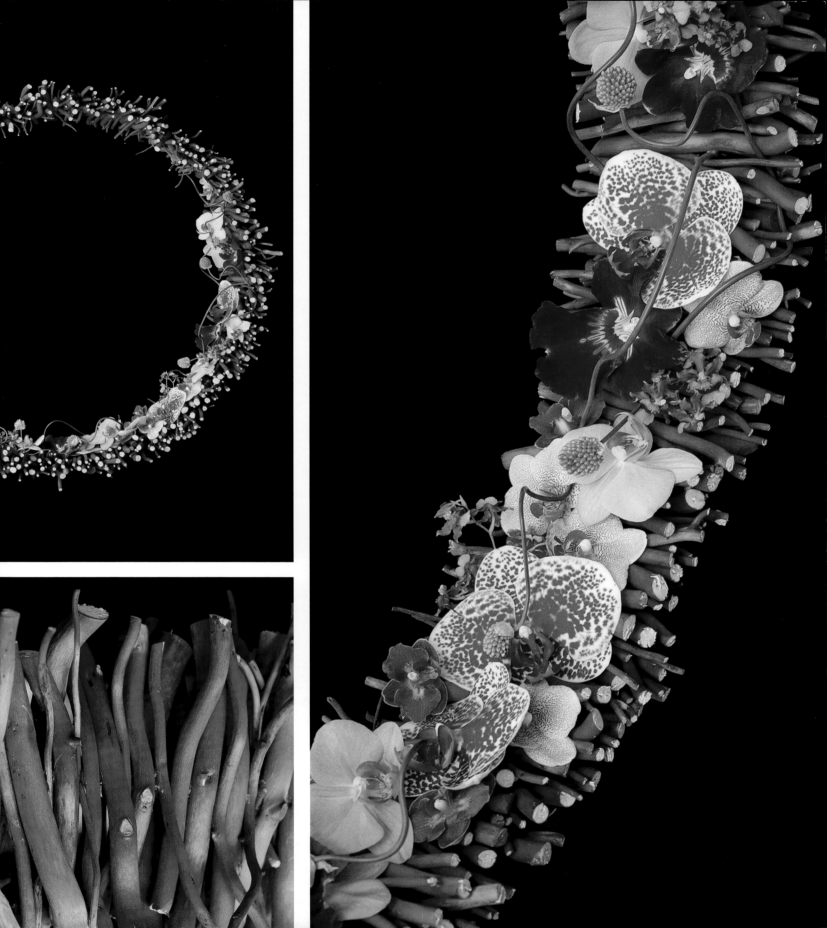

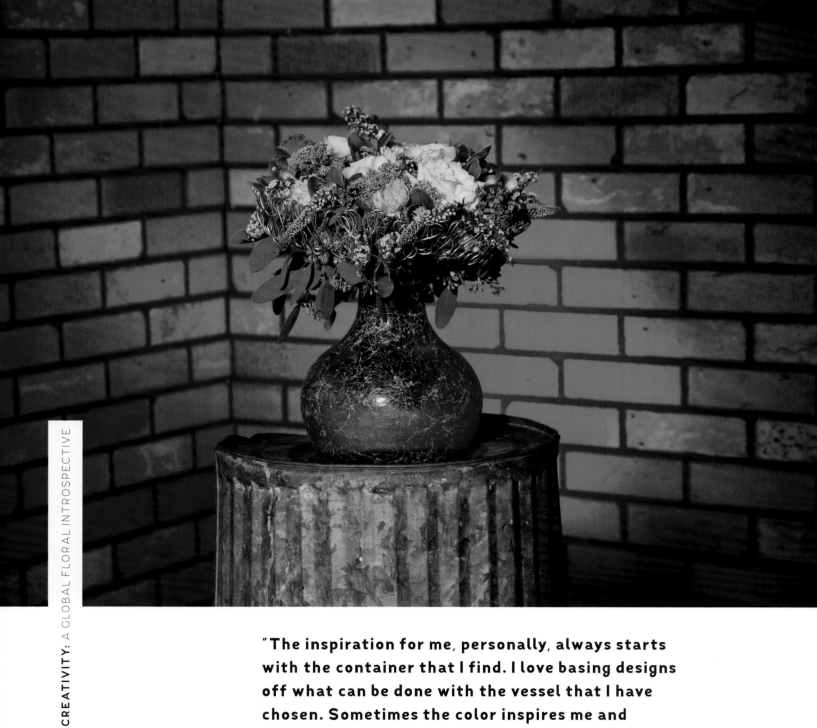

"The inspiration for me, personally, always starts with the container that I find. I love basing designs off what can be done with the vessel that I have chosen. Sometimes the color inspires me and sometimes the shape inspires me. I love starting from there as I find that it makes the flowers shine even more."

TECHNIQUE TIP:
Chicken wire is a great mechanic to hold foliage in a design. Cut the chicken wire to twice the desired shape, fold it in half and weave foliage through the wire. This creates a fantastic collar for potted plants, an armature or any other decorative purpose.

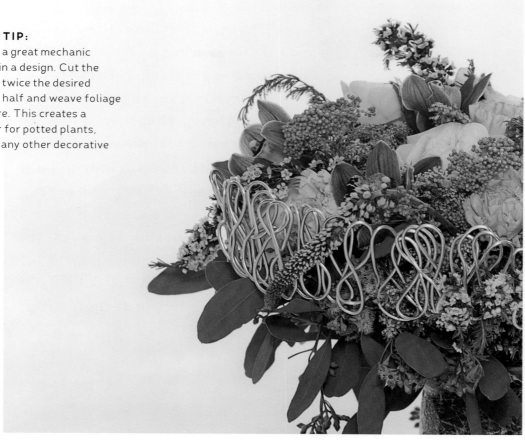

HEATHER DE KOK AIFD, CFD

[CANADA]

Being a family member of Grower Direct Fresh Cut Flowers, Heather has been in the floral industry for 25 years. Branching out on her own as a floral designer, Heather started Heather de Kok Floral Design in Edmonton, Alberta, Canada.

Photography by: Artistic Creations

"The inspiration for my designs comes from everyday objects and informed by my eye for nature. I am drawn to utilizing everyday household and industrial items and then giving them a new function or purpose. I often present them in ways very different from their original intent. I gain pleasure in turning one person's idea of garbage into a creation to be appreciated. The combination of my Northern European coastal heritage with my Southern Californian beach life brings a unique approach to the design."

ANIA NORWOOD AIFD, CFD, CCF, EMC

[U.S.A.]

Ania's Polish heritage and background in civil engineering, architectural design as well as her love of interior design, photography and art have been extremely beneficial in the creation of her floral designs. A floral artist since 2002, she is a freelance designer and owner of Ania Norwood Designs in Laguna Beach, California.

Photography by: Wen Pai, Sowen Studio

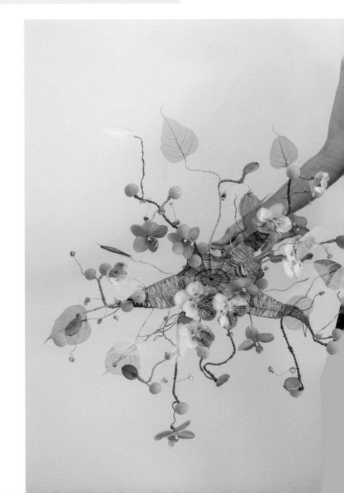

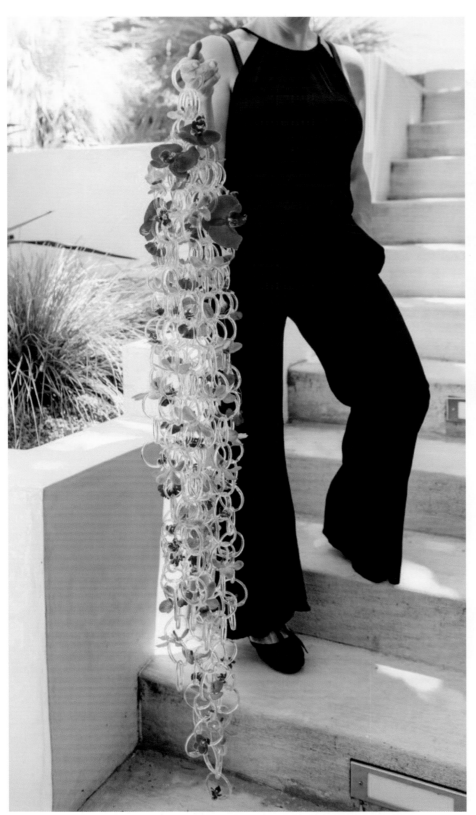

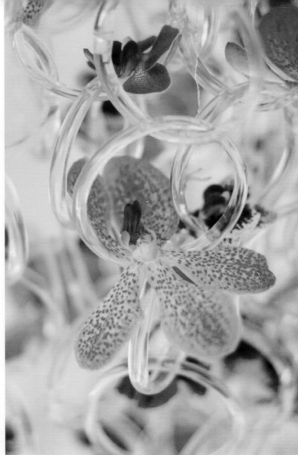

TECHNIQUE TIP:
With this arrangement, thread the fishing line through the predrilled holes and make sure you keep them tight to create enough tension for attaching the water tubes. Use several strings of fishing line so they do not tangle. Always secure the ends with a few double or triple knots, this will prevent the fishing line from untying itself or becoming loose. Also, secure the water tubes at two points, to prevent them from tilting and keep their desired placement. Small zip ties are the fastest and easiest way to attach the tubes to the fishing line.

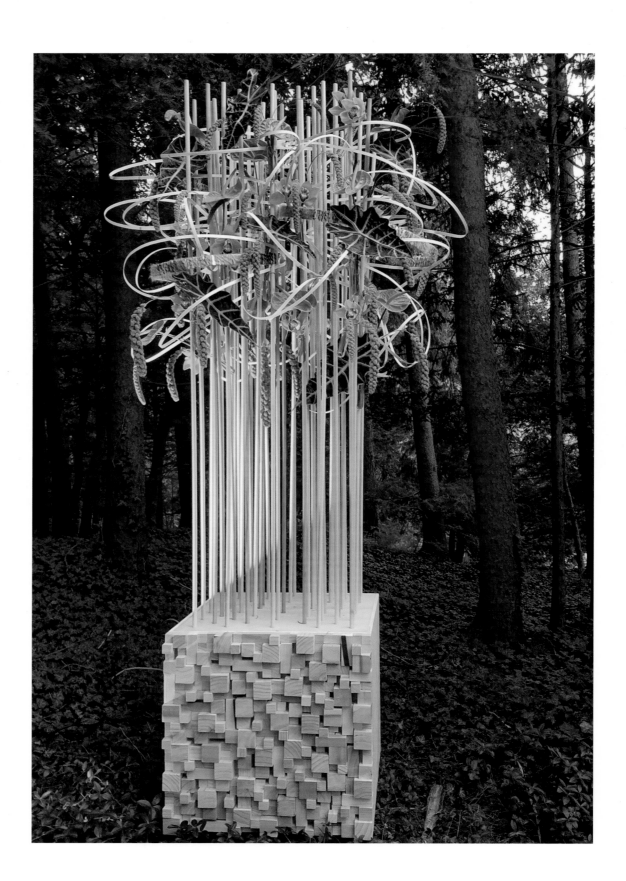

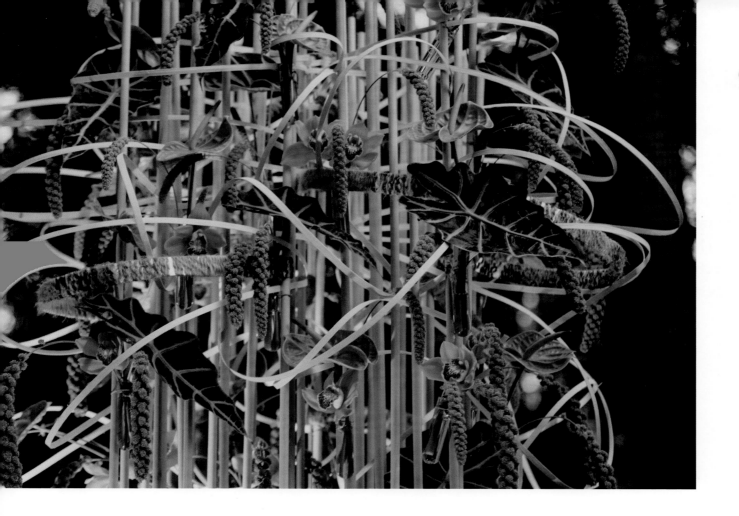

LISA BELISLE AIFD, CFD, CF [U.S.A.]

Owner of Flora Elements Education and Design in Delafield, Wisconsin, Lisa runs a primarily education-based floral design business. She focuses on community floral classes and floral therapy and finds a way to work a story into each piece.

Photography by: Zachera Wollenberg, Katie Alexis, Lisa Belisle AIFD, CFD, CF

"My creativity is inspired by my time in Papua, New Guinea. In other words, Mother Nature. I was surrounded by vast amounts of tropical flowers and foliage. This challenged me to step completely outside my comfort zone and look at everything in a new way. Suddenly, the giant bamboo became a vase, the Monstera air roots became the binding, and the passionflower vines became the choreographer's movement. I try to observe nature, watch patterns, lines and texture and then replicate this in design in a more contemporary version."

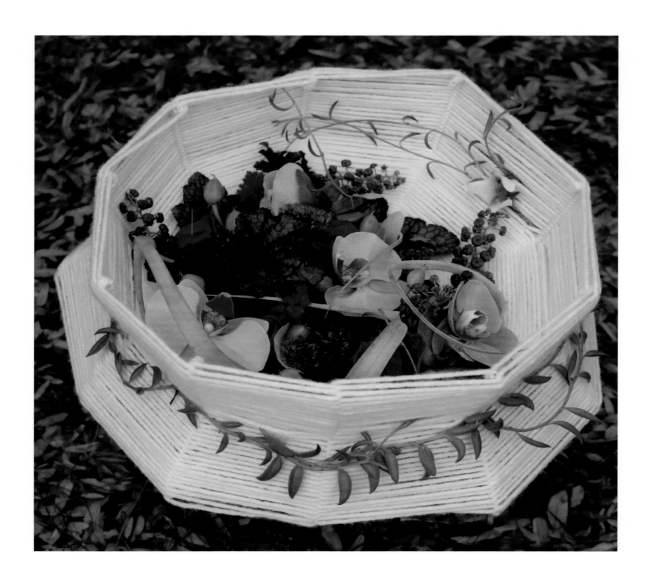

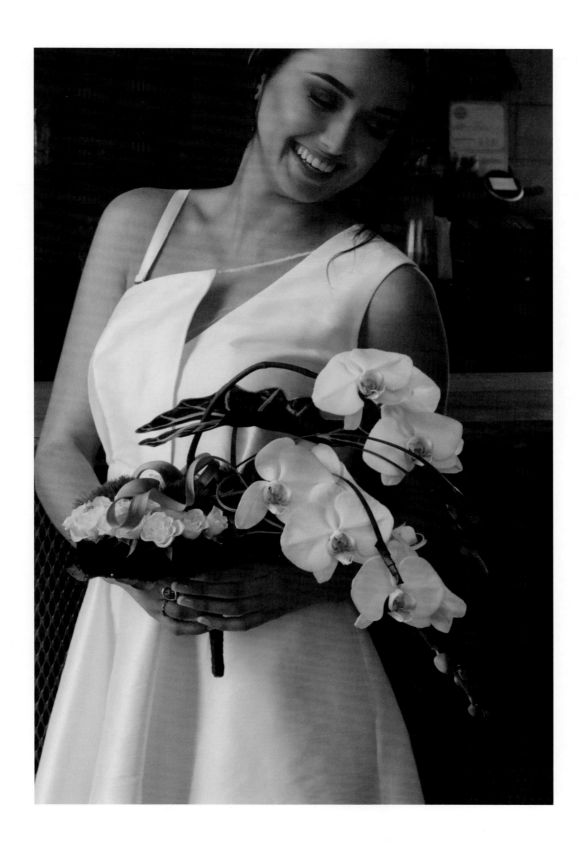

LISA BELISLE AIFD, CFD, CF

TECHNIQUE TIP:
With the modern
Phalaenopsis design,
use a European bridal
bouquet holder and wire,
and wrap the wire with
a fuzzy wool. Pin the
wool-covered wire into
the polyfoam. Create
the modern cascade by
adding two stems of
Phalaenopsis orchids
and a few *Alocasia*
leaves.

RODRIGO "VARITO" VASQUEZ AIFD, CFD, FSMD [U.S.A.]

Born in San Jose, Costa Rica, Varito is owner of R. Varito Designs & Institute, Floral Director at the Special Event Resource and Design Group, and a wedding planner at the National Association of Wedding Professionals Palm Beach, Florida. He has been in the floral wedding industry since 1985. Varito is recognized for his exceptional and out-of-the-box floral jewelry designs.

Photography by: Rodrigo "Varito" Vasquez AIFD, CFD, FSMD

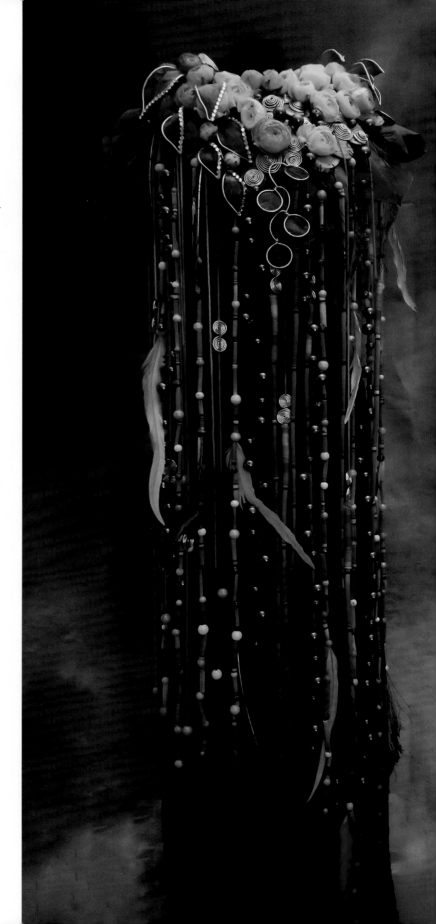

"What inspires me or from where I am inspired can be a poem, a quote, a good or bad day, a beautiful sunrise or sunset. It can be a quiet moment or the lights and music at a disco. It can be a family moment, after a cry or good laugh."

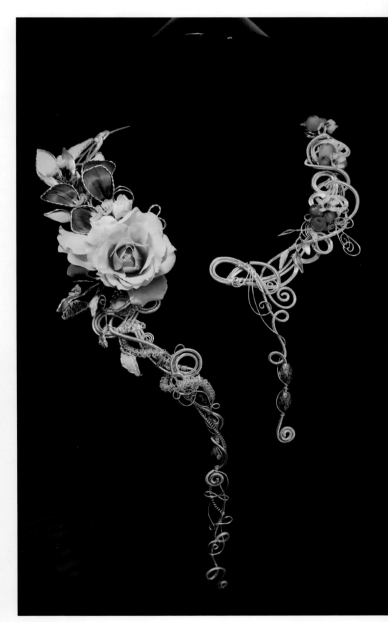

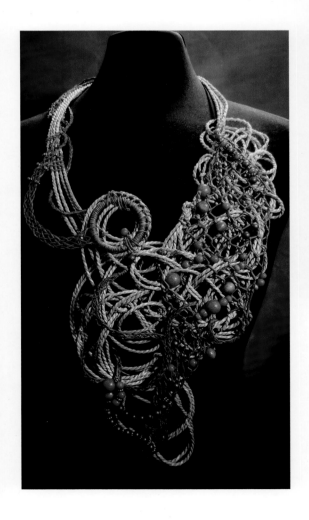

TECHNIQUE TIP:
Give a name to your projects, jobs or creations. By reflecting, you can understand what inspires you and will inspire others.

TECHNIQUE TIP:
For this arrangement, the key is to first find a piece of wood for the base. Cut a piece of dried styrofoam the same size as the base; glue them together. Nail in "feet" to each corner and wrap them with paper covered wire. Add on decorative pieces and a band of moss ribbon. Place water tubes into the foam. Then, add the botanicals creating layers.

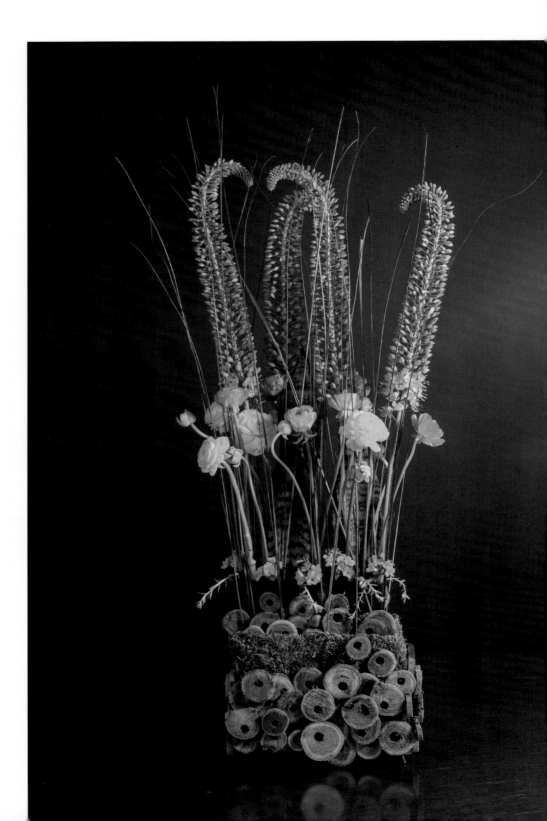

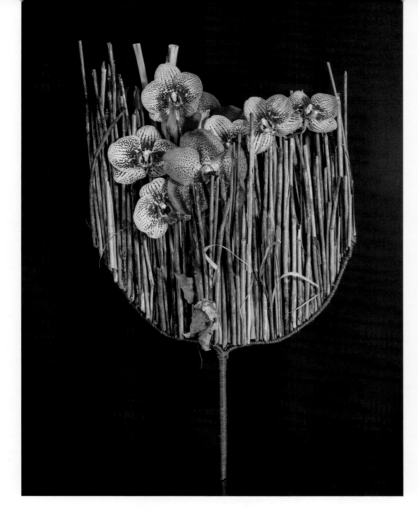

"As for the inspiration, I explore the incredible use of materials, plants and flowers. This is my everyday artistic evolution. I find passion in pushing the boundaries of American floristry, promoting the art form in a fresh and modern way."

JENNY THOMASSON AIFD, CFD, PFCI, EMC [U.S.A.]

A florist and retail flower shop owner for over 20 years, Jenny is the owner of Jenny T. Floristry and Design Consultant at Stems Florist in St. Louis, Missouri. Her love for the industry has led her to become a floral educator and floral entrepreneur.

Photography by: Pam's Photography

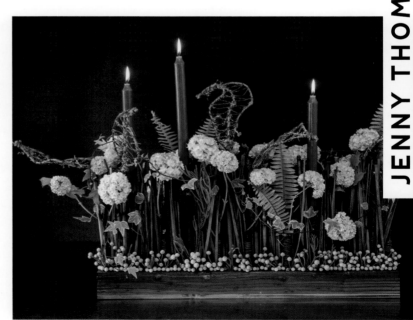

JENNY THOMASSON AIFD, CFD, PFCI, EMC

TECHNIQUE TIP:
To control an element, wire, tape and then glue the material together. This creates one insertion into your design and allows you to control the placement. Your material will stay were you place it.

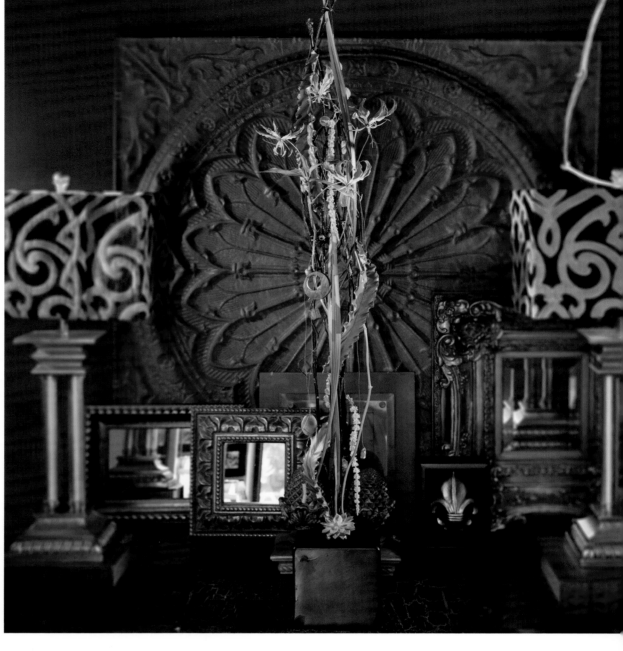

MICHAEL WHALEY AIFD, CFD [U.S.A.]

Michael has over three decades of experience in the floral industry and has been involved with every aspect during his career. He has a passion for continuing self-education and, more importantly, sharing that acquired knowledge with other designers in the industry. Michael currently works as creative director for Fresh Affairs, an upscale wedding and special events studio based in Raleigh, North Carolina.

Photography by: James Walters, Walters and Walters

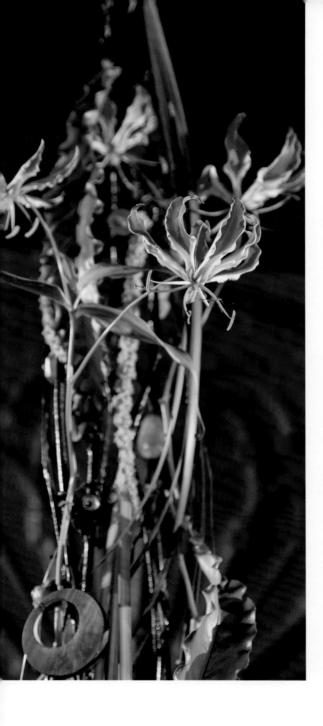

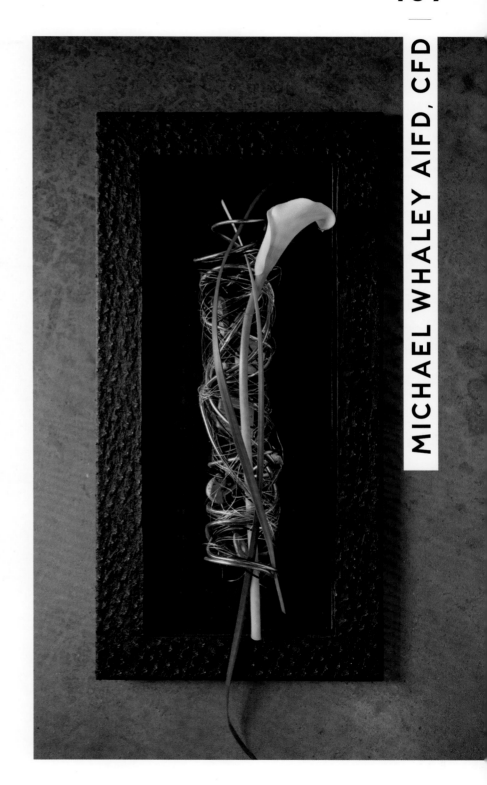

MICHAEL WHALEY AIFD, CFD

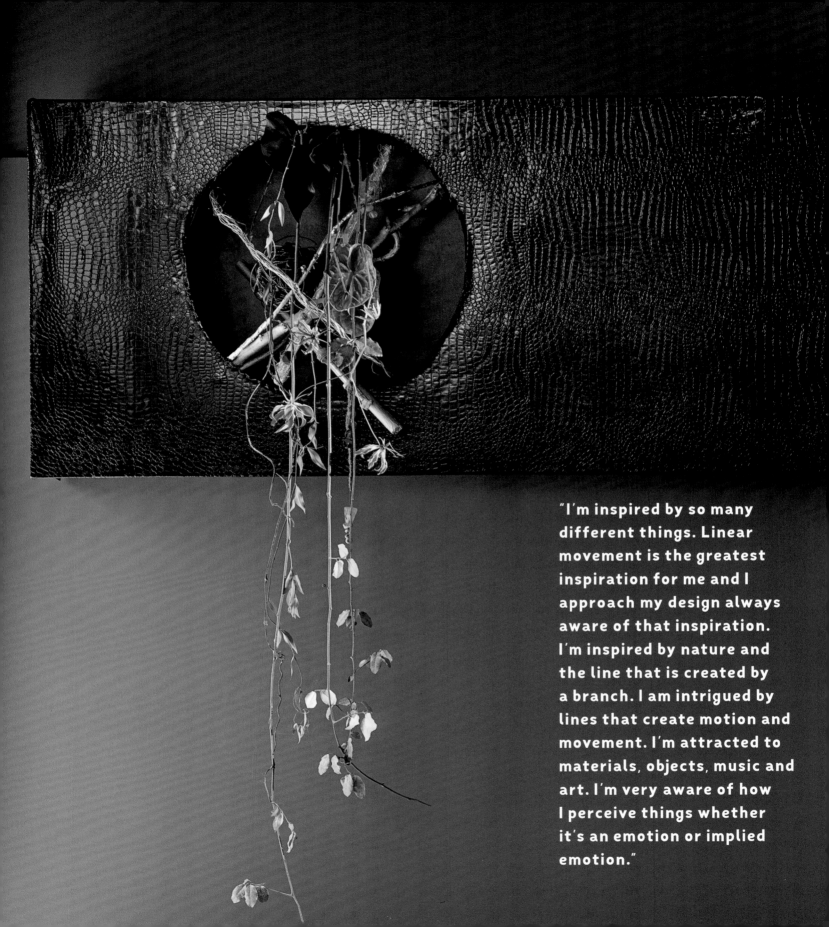

"I'm inspired by so many different things. Linear movement is the greatest inspiration for me and I approach my design always aware of that inspiration. I'm inspired by nature and the line that is created by a branch. I am intrigued by lines that create motion and movement. I'm attracted to materials, objects, music and art. I'm very aware of how I perceive things whether it's an emotion or implied emotion."

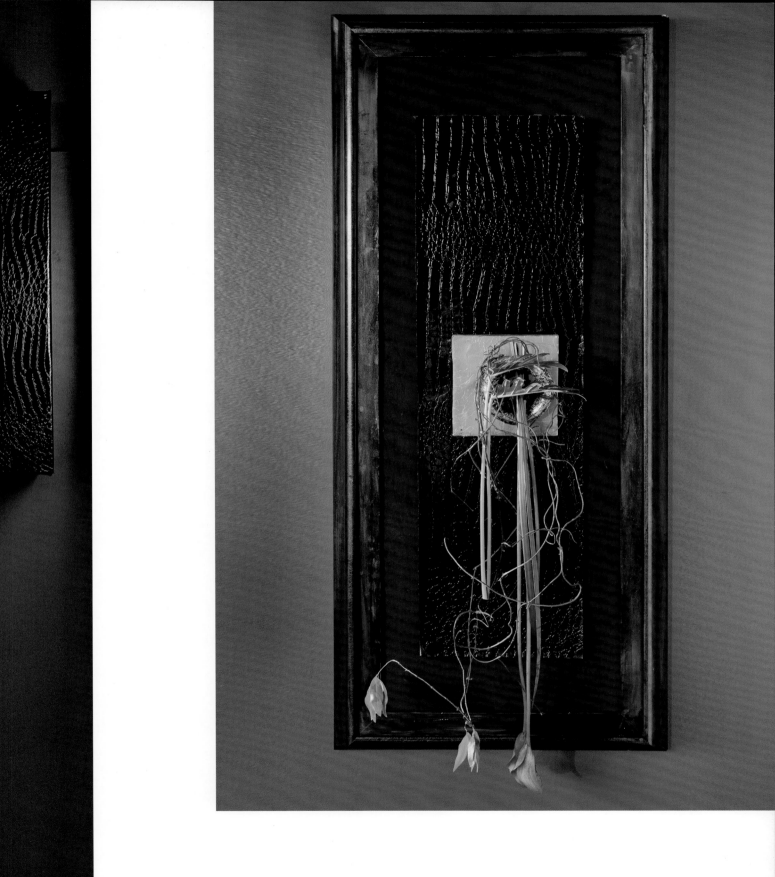

STACEY CARLTON AIFD, CFD, EMC

[U.S.A.]

As an artist, Stacey celebrates the value in the vast diversity of the floral industry by wearing many hats. She is an educator, consultant, event designer, magazine contributor and product developer. As the owner of The Flora Culturist in Riverside, Illinois, she energetically expresses her ever-evolving point of view with unexpected materials and unique combinations of botanicals.

Photography by: Stacey Carlton AIFD, CFD, EMC

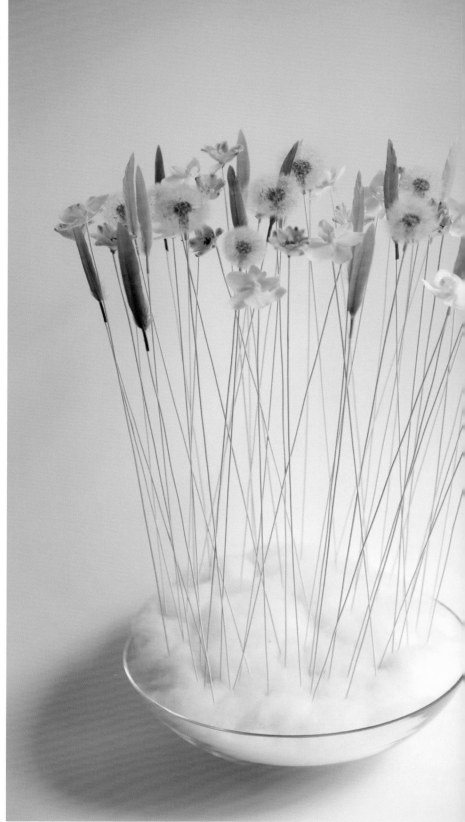

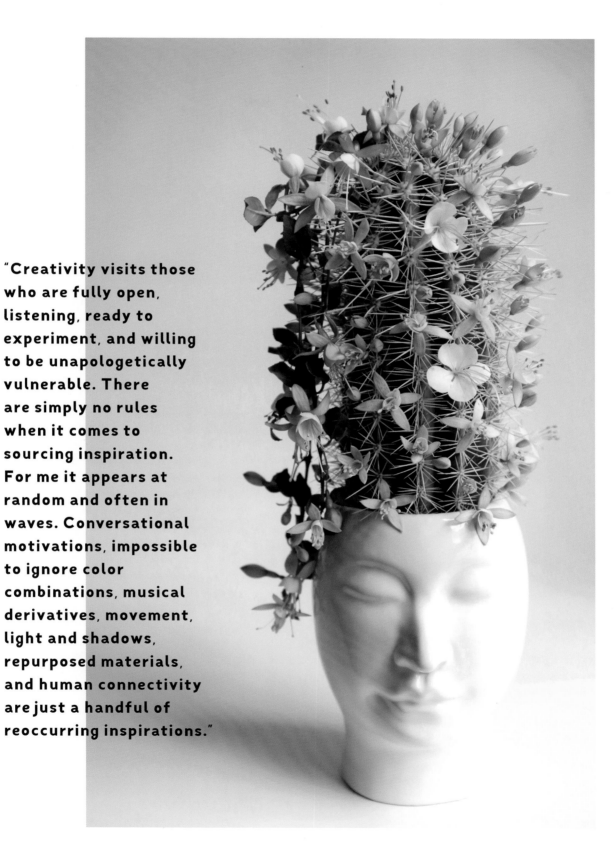

STACEY CARLTON AIFD, CFD, EMC

"Creativity visits those who are fully open, listening, ready to experiment, and willing to be unapologetically vulnerable. There are simply no rules when it comes to sourcing inspiration. For me it appears at random and often in waves. Conversational motivations, impossible to ignore color combinations, musical derivatives, movement, light and shadows, repurposed materials, and human connectivity are just a handful of reoccurring inspirations."

"Often ideas evolve during the creative process picking up momentum during practical application. By being open, nurturing the concepts, and letting them grow during the design process creativity becomes incredibly powerful and therefore will breed even more creativity."

Stacey Carlton AIFD, CFD, EMC
Owner of The Flora Culturist
Riverside, Illinois

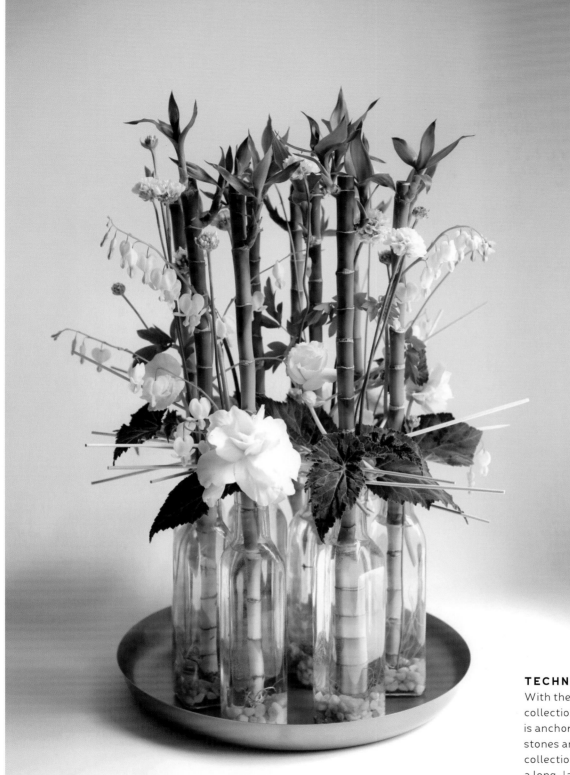

STACEY CARLTON AIFD, CFD, EMC

TECHNIQUE TIP:
With the vertical bamboo bottle collection, the *Dracaena braunii* is anchored with decorative stones and grouped in a collection of glass bottles offers a long-lasting, strong base for a natural flower support in this composition. When bamboo skewers are crisscrossed and secured to the *Dracaena braunii*, a versatile structure is created.

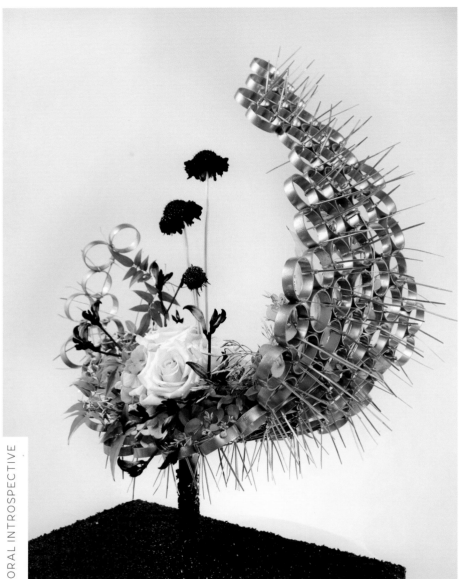

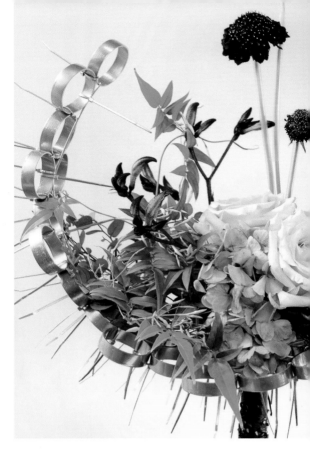

TECHNIQUE TIP:

It is advisable to always begin your armatures with some sort of thick wire, metal frame or skeleton. This helps strengthen the creation and allows the construction to bear the weight of the flowers and other decorative elements.

114

SAMANTHA BATES AIFD, CFD, CF [U.S.A.]

Entering into the floral industry in 2011, Samantha is the owner and head designer of Especially For You Floral in Ponchatoula, Louisiana. She is an avid competitor in floral competition where she has won many honors.

Photography by: Samantha Bates AIFD, CFD, CF

"I've always been inspired by geometric shapes, especially spheres and circles. I love the continuity, the unbroken and consistent existence that a circle or sphere displays. I pull inspiration from everyday objects. Taking an ordinary object, such as a ping pong ball, in large numbers and using it repetitively to form an armature is another one of my passions in floral design. Seeing the beauty in the little things lying around and reimagining them into works of art."

SAMANTHA BATES AIFD, CFD, CF

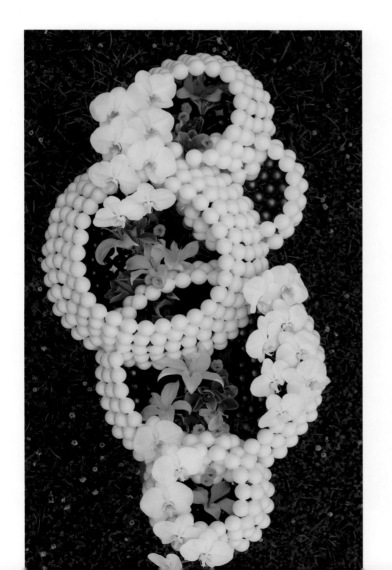

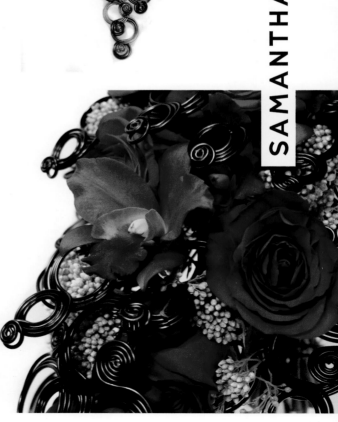

"Since I was born and brought up in India,
it has a deep influence on my creativity!
Emotions, human touch and spirituality
is the soul of creativity for me. Without
soul how can I draw my expression?"

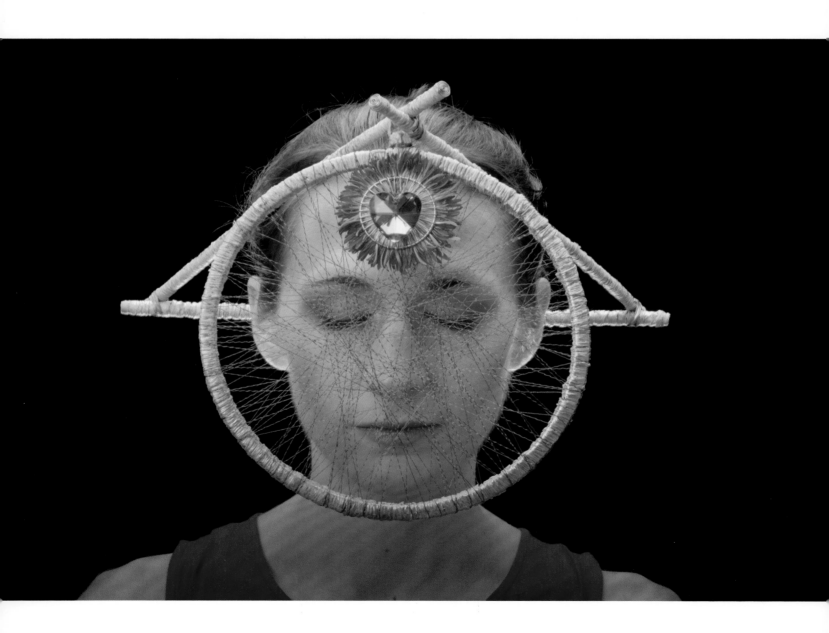

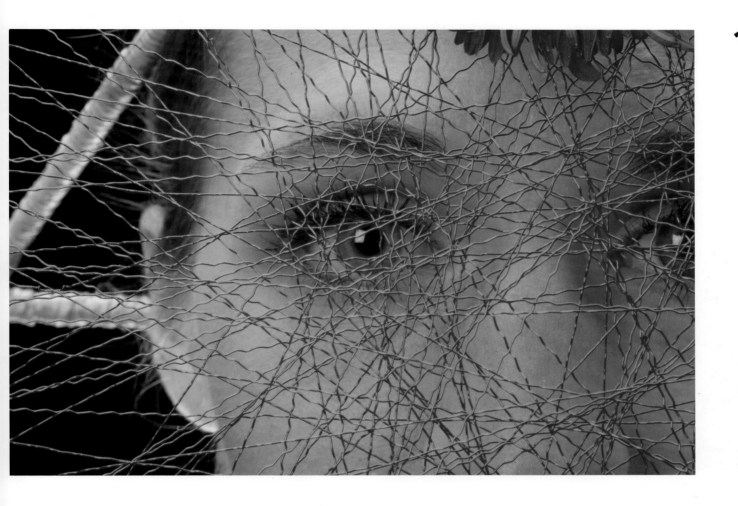

RUPALI SHETE SADALAGE AIFD, CFD
[U.S.A.]

Originally from India, a science graduate who wanted to become a doctor, Rupali channeled her energies into interior design. Realizing her passion for creativity, she eventually became a floral designer. She is a freelance designer and owner of Rupali Shete in the Chicago, Illinois Area.

Photography by: Erich Schrempp, Rupali Shete Sadalage AIFD, CFD, Trinity Valentino

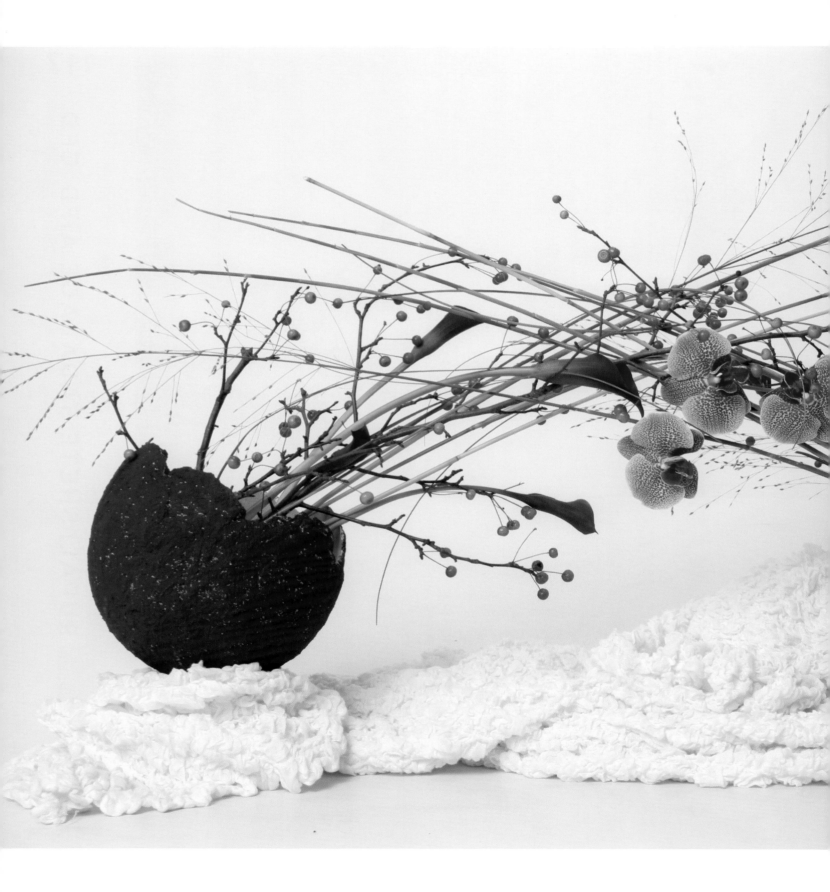

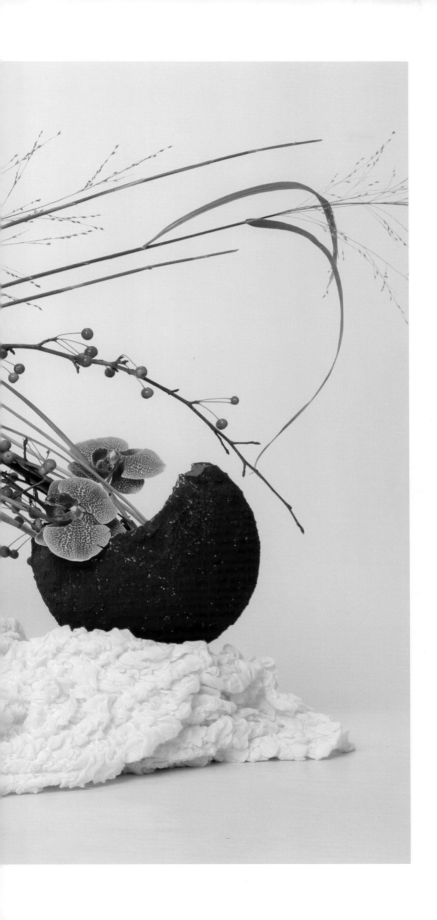

RUPALI SHETE SADALAGE AIFD, CFD

TECHNIQUE TIP:
To create a handmade vase, use a mortar mix. In a paint bucket, mix the mortar with water until your mixture is of an oatmeal consistency. Inflate the 12-inch balloon and place it on the flower vase. Apply the mortar mixture until you arrive at your desired shape. Let the form dry for a day and then slowly let the air out of the balloon. The artifact can be painted to whatever color desired.

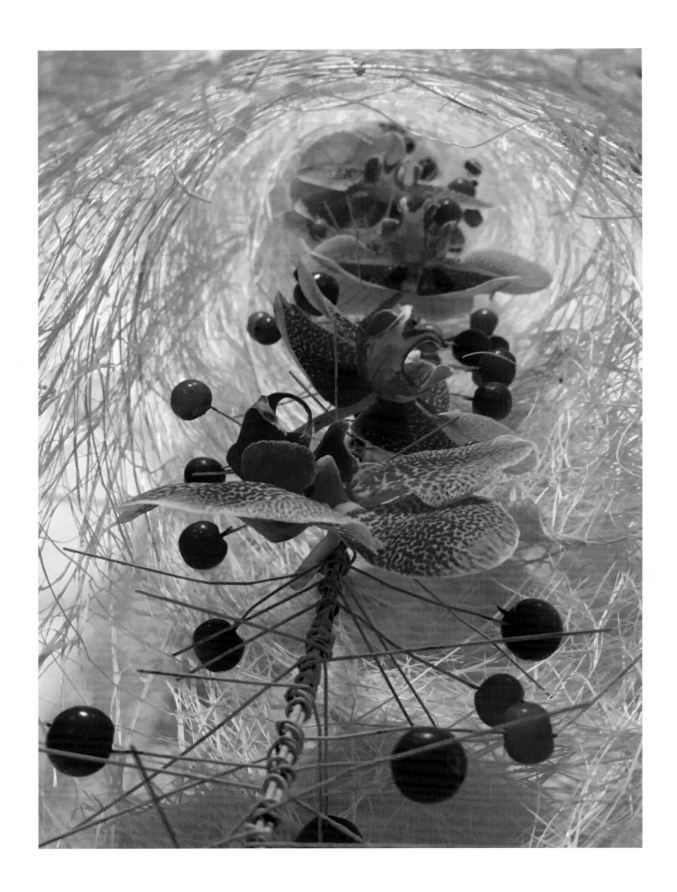

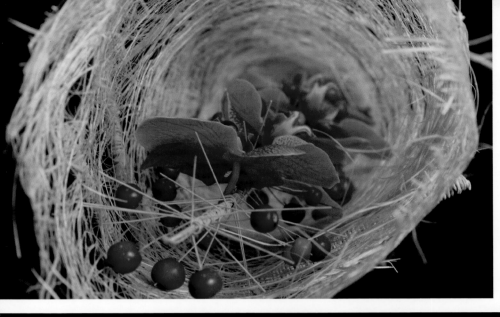

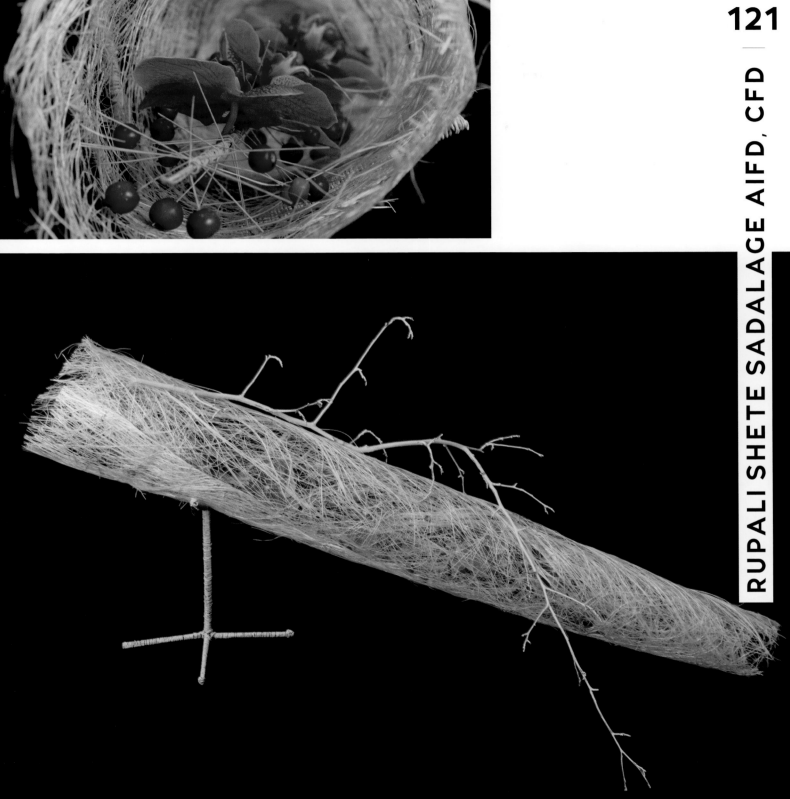

ADRIANNA DURAN-LEON AIFD, CFD

[U.S.A.]

A florist for 26 years, Adrianna grew up in the floral industry working in her Aunt's floral shop. She is the owner of The Flower Company in Albuquerque, New Mexico.

Photography by: Adrianna Duran-Leon AIFD, CFD

"Inspiration for me comes in many ways. It really depends on the design as to where that inspiration comes from. It can come from an emotion, a story a client is telling me, a flower that stands out or even a container. That's always a tough question for me to answer because inspiration can come from literally anywhere."

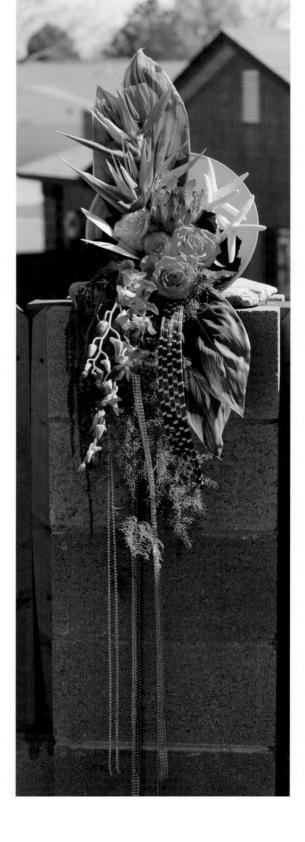

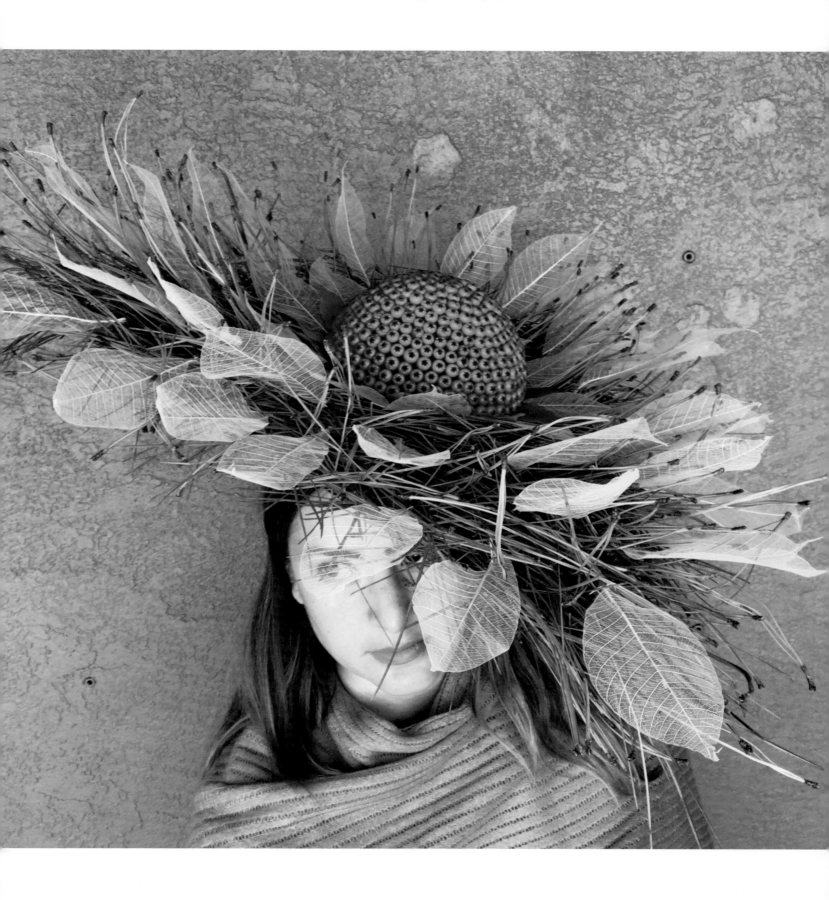

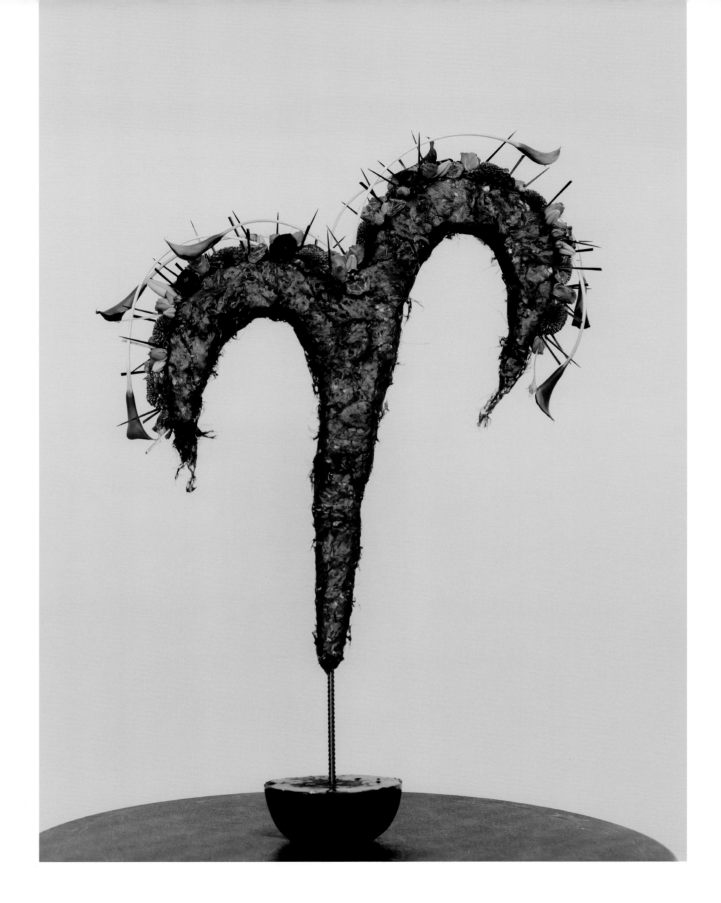

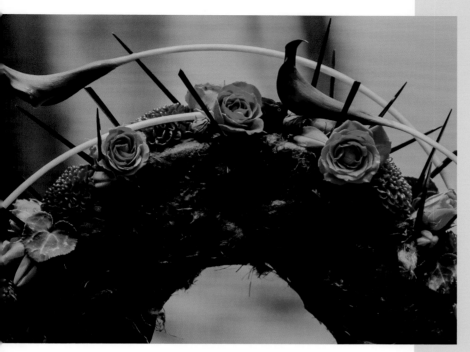

GARRETT SKUPINKSI CF [U.S.A.]

An internationally floral designer, Garrett creates high couture experimental design styles and unique large-scale displays. His passion for floral education and design has taken him throughout the United States, Canada, and multiple countries in Europe learning, teaching and designing.

Photography by: Garrett Skupinksi CF, HZ Photography, Justin Lehman Photography

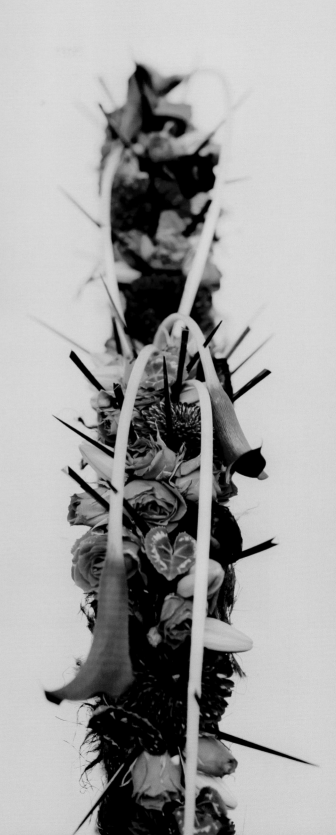

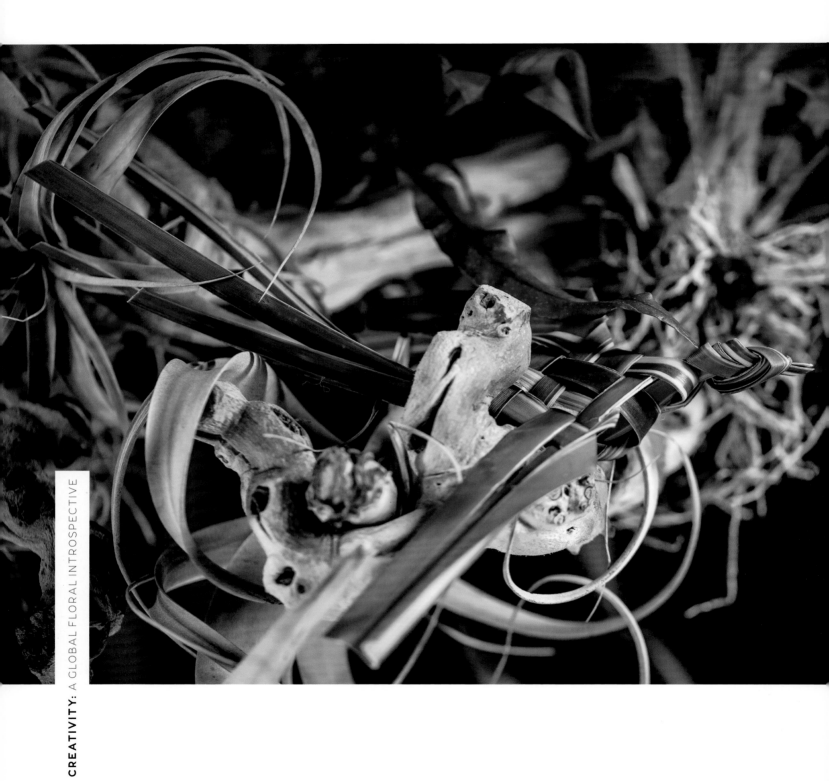

126

"Our senses are the most powerful tool for inspiration that we possess, and they are what really powers my creative process. Floral design is completely limitless, so my designs are influenced from the second the sky lights on fire with the perfect sunset to the intrigue of fictional stories; this keeps my creativity ever changing."

GARRETT SKUPINSKI CF

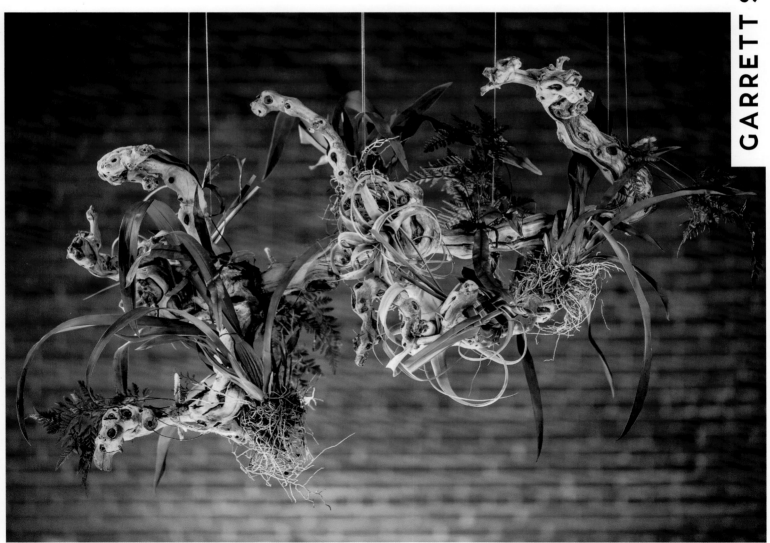

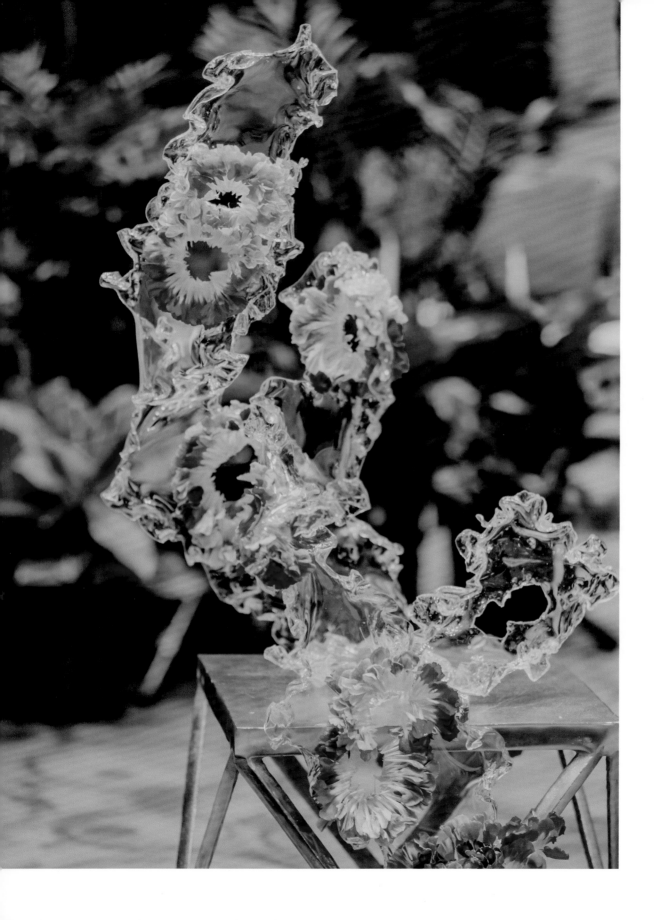

TECHNIQUE TIP: Adhesives are a powerful mechanical friend for almost any surface. As long as you clean your surface, you can create any shape or movement with your glue dots which allows you to then construct something captivating with your floral products.

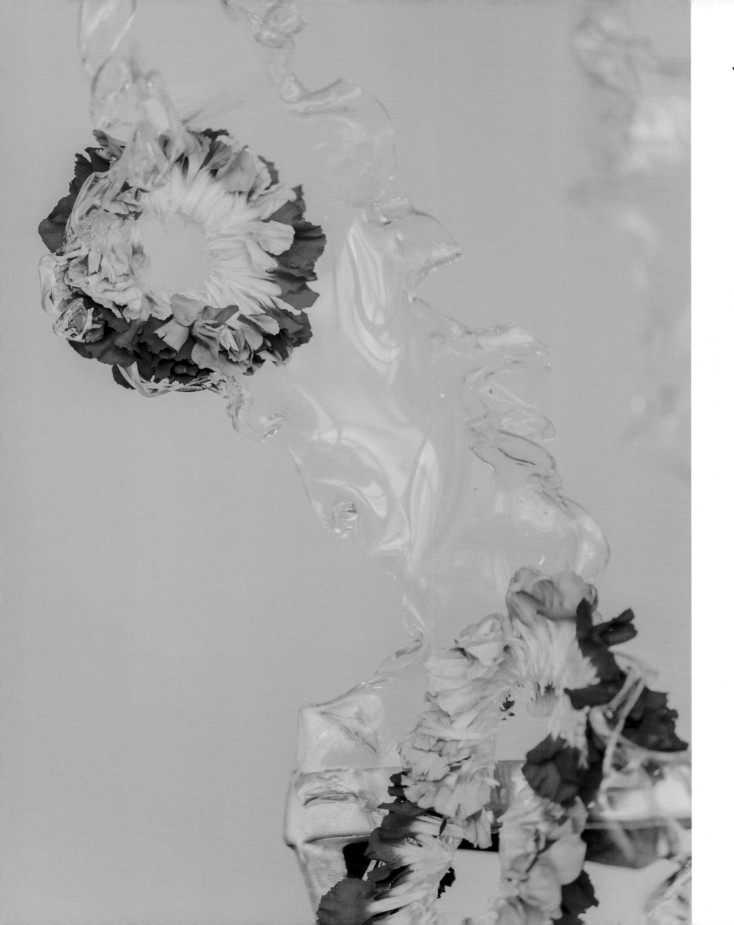

GARRETT SKUPINSKI CF

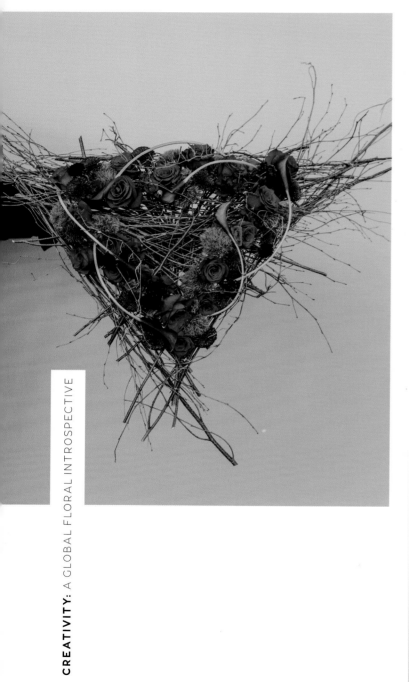

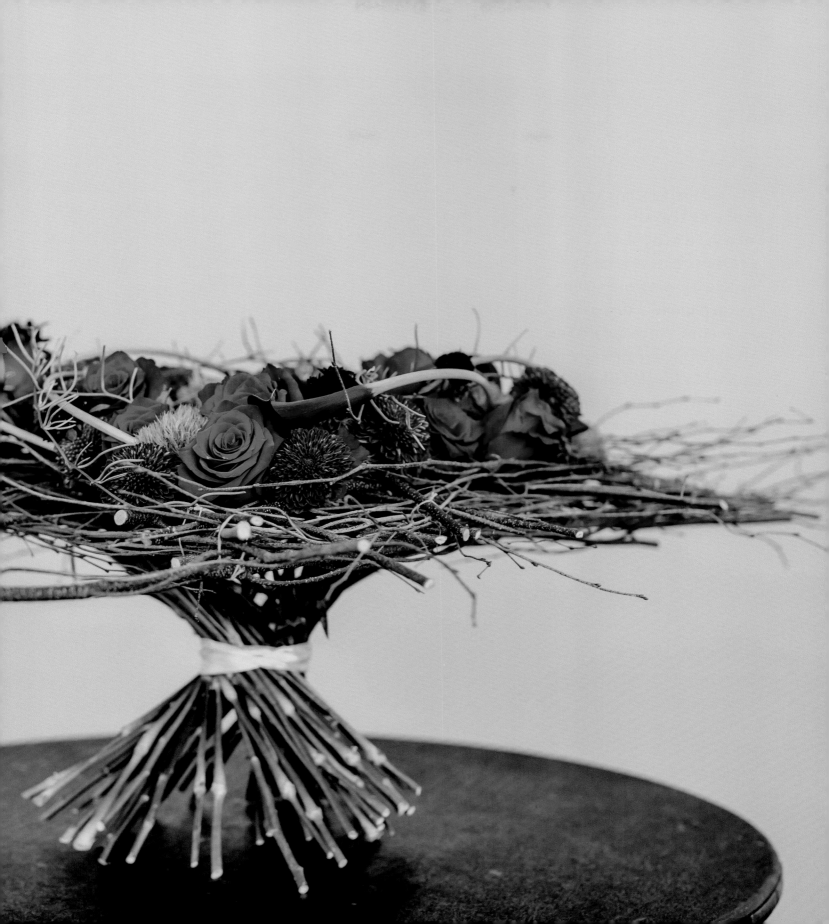

"My curiosity fuels my hobby of traveling. I marvel about the different cultures that inspire my artwork. Once I return home, I translate my feelings into my pieces. Also, living in constant cold in Chicago, I like to keep my flowers warm with knit and crochet constructions."

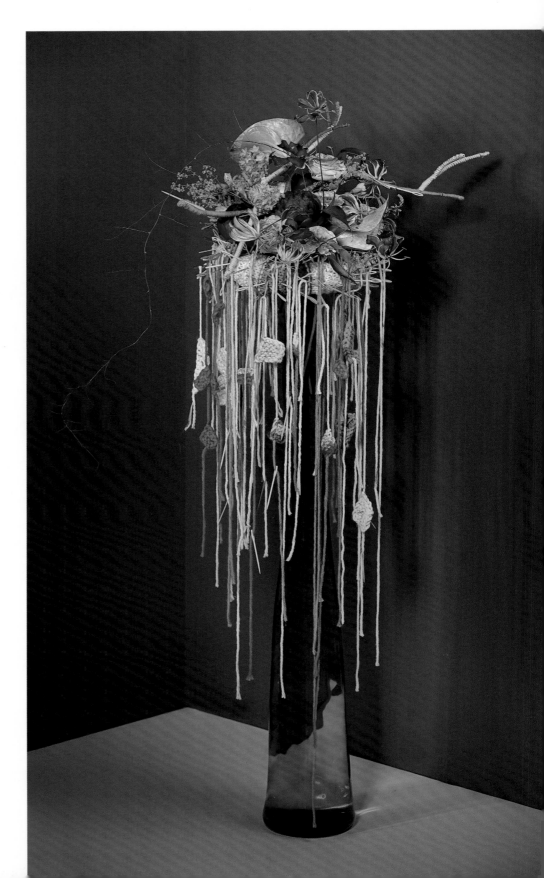

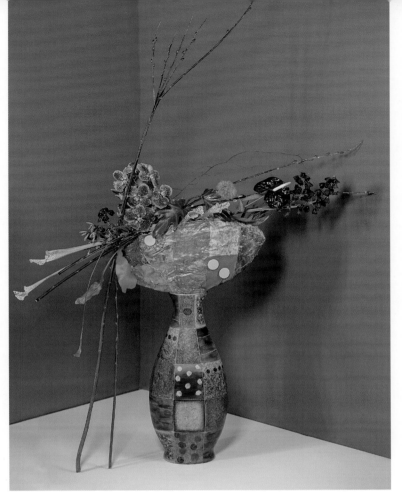

TECHNIQUE TIP:
To create a floral
object, pick a unique
shaped container.
Cover the container
using the handmade
paper maché method.
Use floral foam in your
container to insert the
botanical materials.

OLENA TCACI AIFD, CFD, EMC

[U.S.A.]

Owner of Dandelion Floral Art Salon in the Northern
Suburb of Chicago, Illinois, Olena incorporates her
engineering education and background in fashion
design into her floral designs. Original from the
Ukraine, she also travels around the world to
participate in international floral installations.

Photography by: Igor Vilk

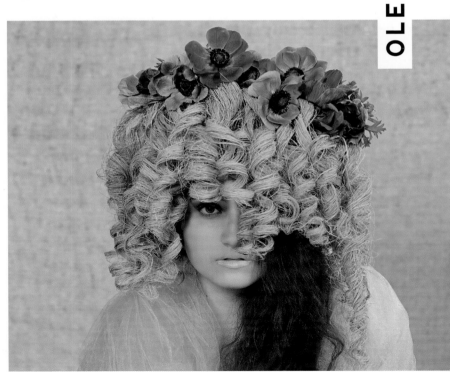

ARTHUR WILLIAMS AIFD, CFD, EMC, CF

[U.S.A.]

With a background in gardening, sculpture and photography,
Arthur has been in the florist industry since 1996. Known for
his floral headdresses and the use of natural tension in his work,
Arthur is the owner of Babylon Floral Design in Denver, Colorado.

Photography by: Amanda Baker

TECHNIQUE TIP:
When painting botanicals,
I always do layers of multiple
colors and apply before dry.
I try to mimic nature's color
gradient but in an unnatural
way, for example burgundy
to black, red to copper.
By applying coats over wet
layers, it's easier to get a soft
transition between colors.

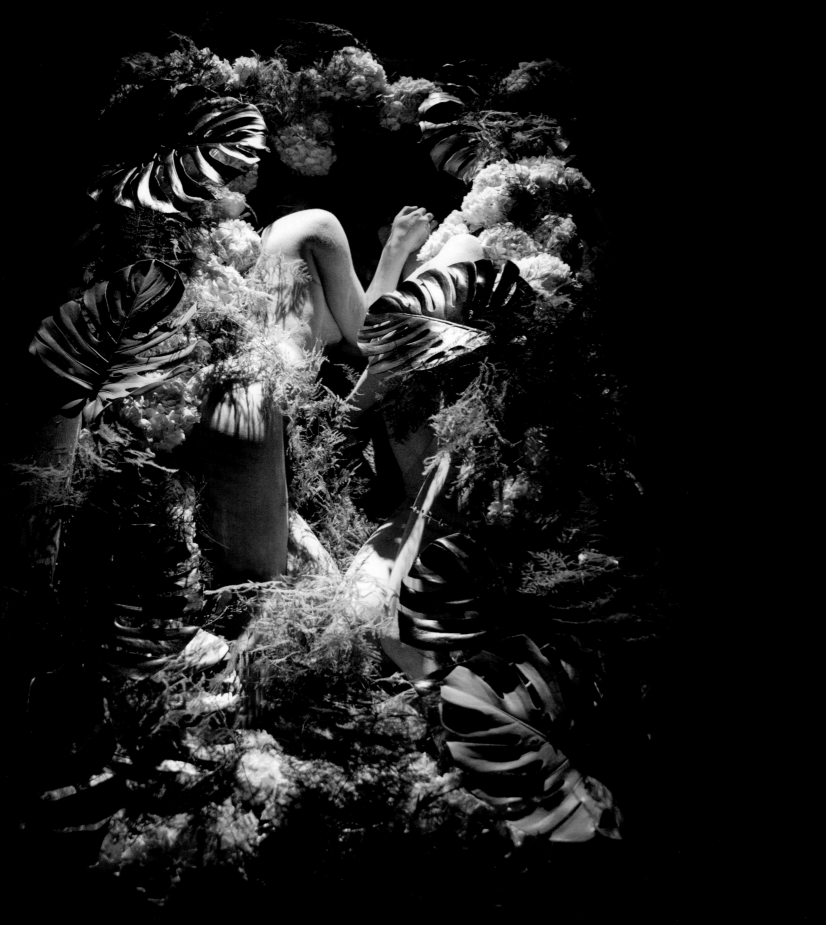

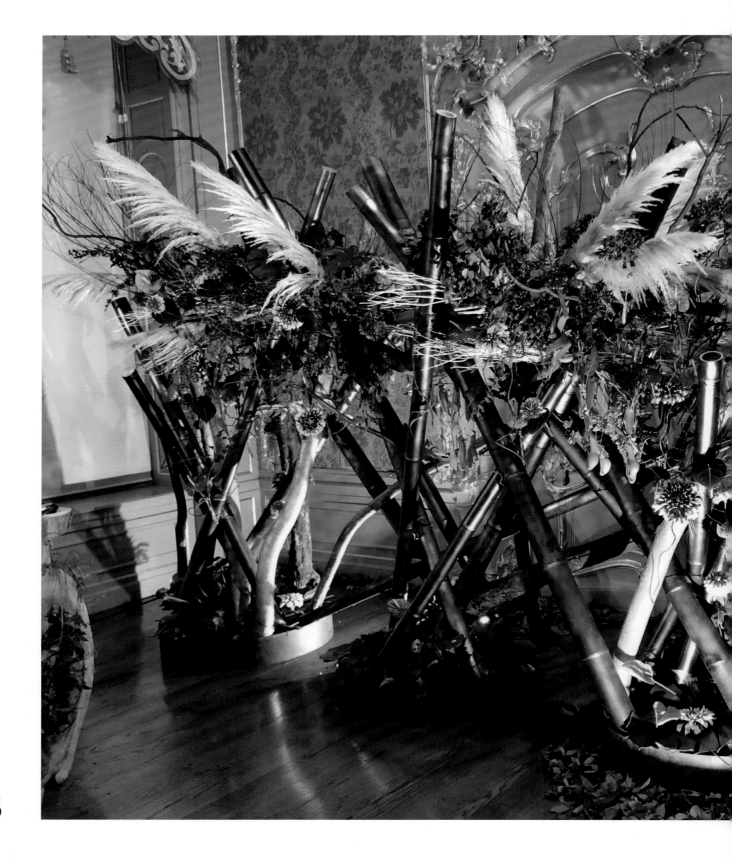

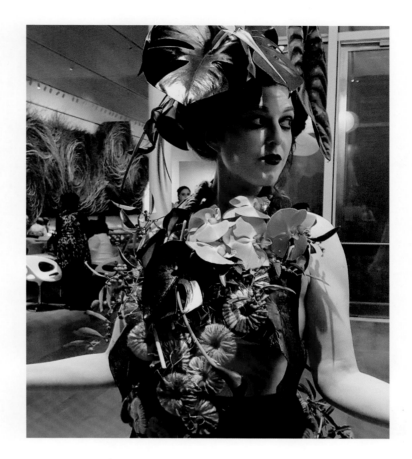

ARTHUR WILLIAMS AIFD, CFD, EMC, CF

"An organic medium demands an organic process, and each placement dictates the next. Layers, color, texture are all informed by the structure, which comes from the plants themselves. Contrast and harmony blend into each other and unify. The very nature of living materials makes them impermanent. There is perfection in the imperfections of nature's sculptures, and bringing them together in simple, striking beauty."

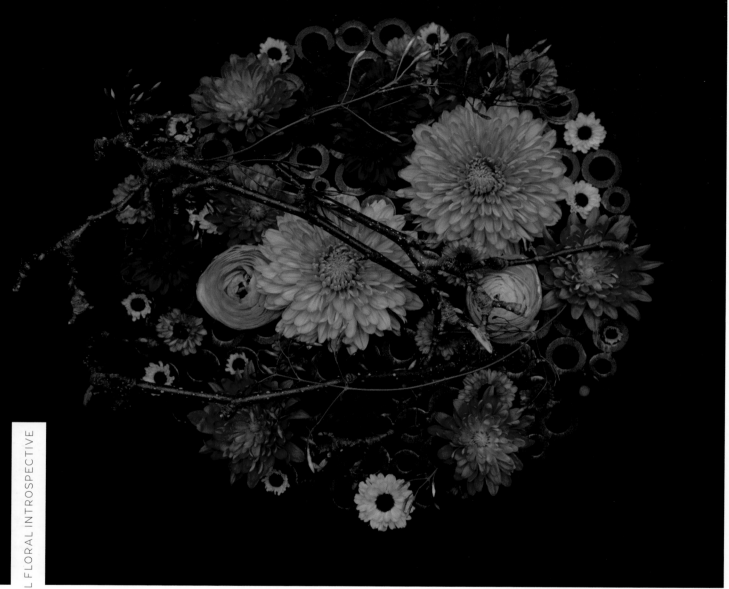

138

LEA ROMANOWSKI AIFD, CFD, CAFA

[CANADA]

As a singer, dancer, painter and floral artist for the past 36 years, Lea is the owner of Designing on the Edge in Calgary, Alberta, Canada. She enjoys telling stories through her work and has a reason for each piece she creates.

Photography by: Rafal Wegiel Photography

"My biggest inspiration is being challenged.
If you tell me it is impossible, I will create
it into action. I am inspired by what the
possibilities are. I ask myself, how difficult
is it. Basically, if you can conceive it, you can
achieve it."

LEA ROMANOWSKI AIFD, CFD, CAFA

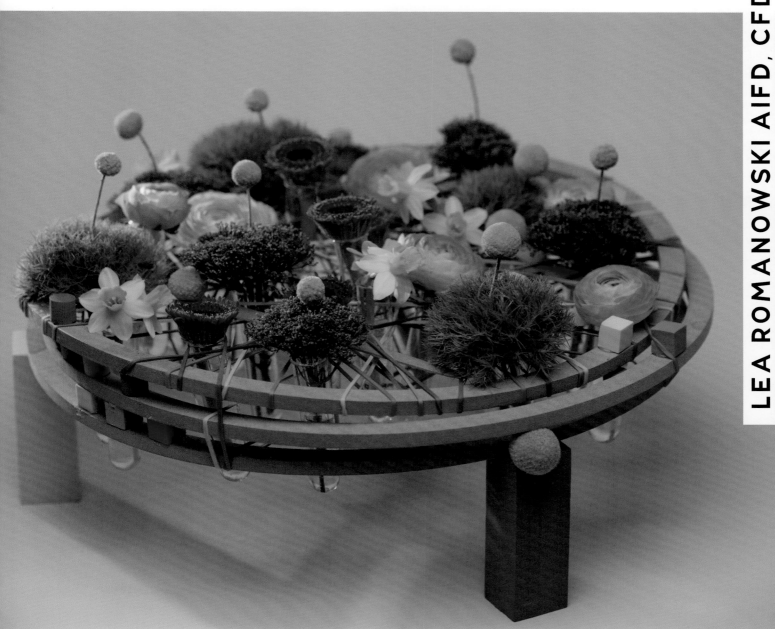

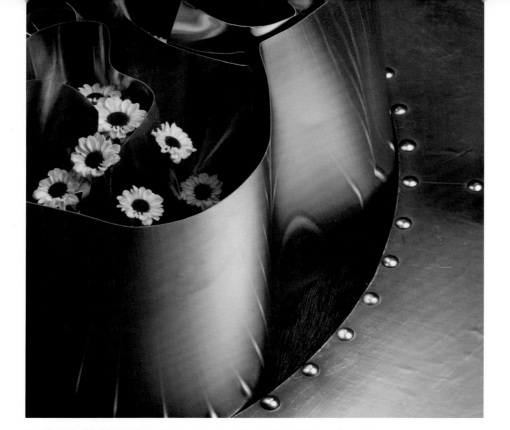

TECHNIQUE TIP:
With the metal art piece, clean your daisy stems and spray them black. This way the black gives a continuity with the piece between the metal and the white petals.

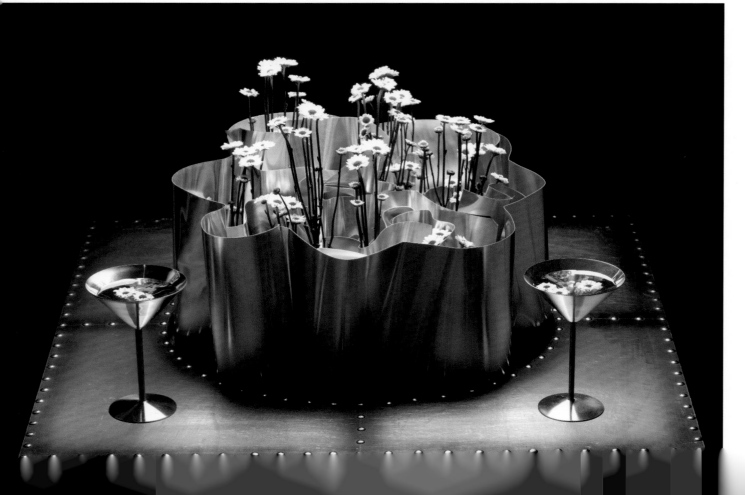

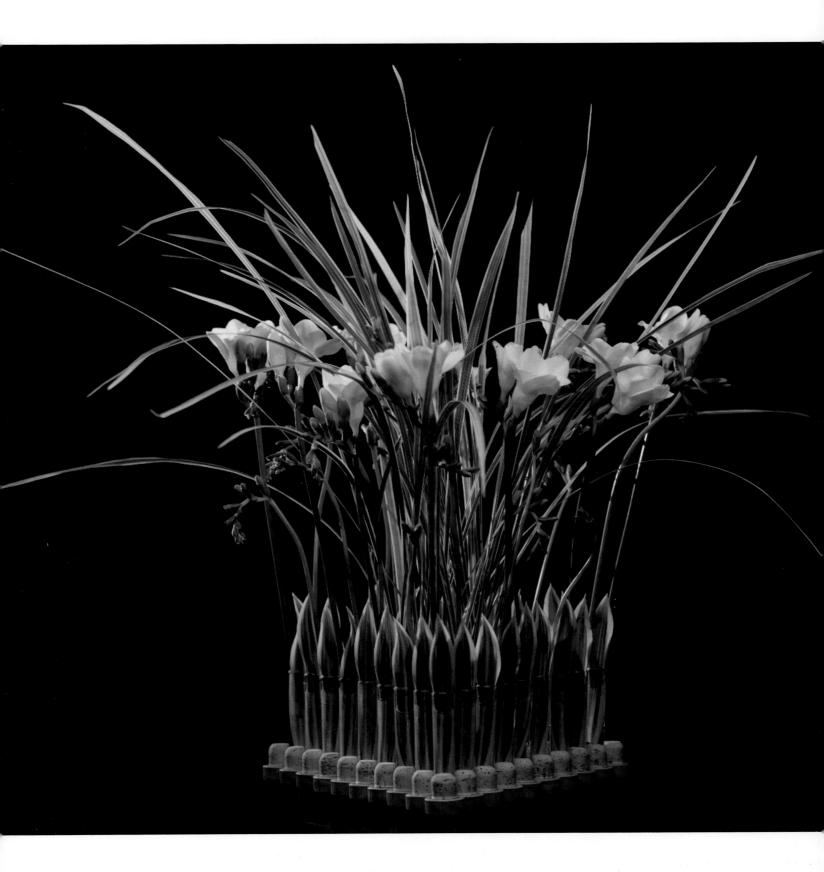

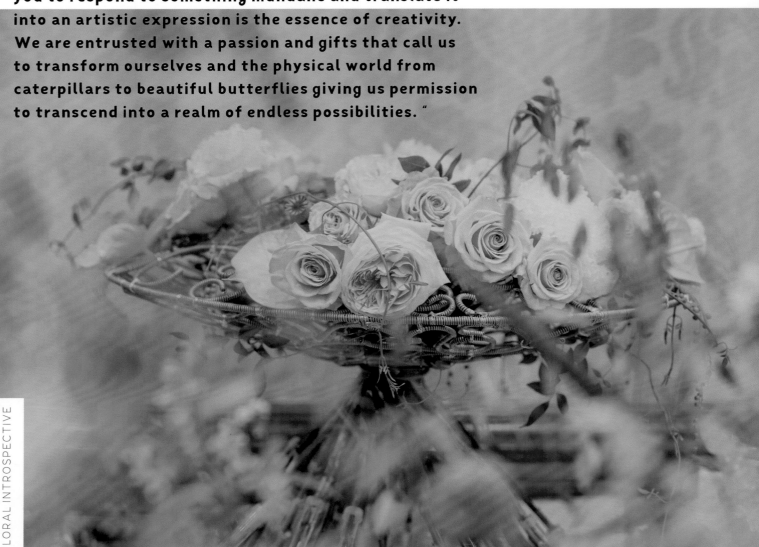

"Listening to that little internal voice that commands you to respond to something mundane and translate it into an artistic expression is the essence of creativity. We are entrusted with a passion and gifts that call us to transform ourselves and the physical world from caterpillars to beautiful butterflies giving us permission to transcend into a realm of endless possibilities."

142

JULIA MARIE SCHMITT AIFD, CFD, ICPF, EMC, PFCI

[U.S.A.]

An international floral artist, presenter and educator, Julia began her floral career in 2008 when she started designing at her mother's "retirement hobby flower shop." It did not take long for flowers to become her passion and her life. She travels the global sharing her passion with designers as well as conducts floral art workshops for all educational levels at her floral studio and flower shop Flowers by Julia Marie in rural Marceline, Missouri.

Photography by: Brandon Yamaguchi Photography, Maureen Christmas AIFD, CFD, EMC

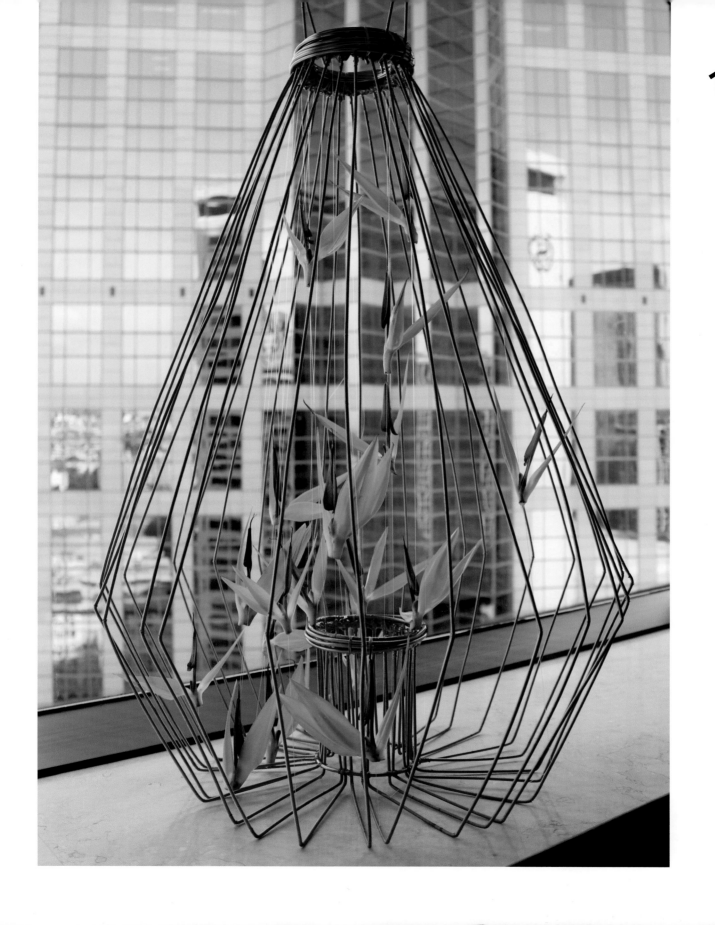

JULIA MARIE SCHMITT AIFD, CFD, ICPF, EMC, PFCI

"Creativity is a lovely, but fragile blossom. Creativity cannot be forced nor confined to a timeline. Just as a flower must be nurtured with good soil, water and sunshine to grow. Creativity requires a good understanding of design theory plus a strong foundation of skills and techniques. This combined with time, silence, exposure to nature, and passion, allows creativity to emerge into a most fabulous blossom. Like a wildflower, seemingly unplanned and effortless."

Leanne Kesler AIFD, CFD, PFCI
Co-owner of the Floral Design Institute
Portland, Oregon